THE
BRITISH
MUSEUM

THE LANDMARK LIBRARY

Chapters in the History of Civilization

The Landmark Library is a record of the achievements of humankind
from the late Stone Age to the present day. Each volume in the series
is devoted to a crucial theme in the history of civilization, and offers
a concise and authoritative text accompanied by a generous
complement of images. Contributing authors to The Landmark
Library are chosen for their ability to combine
scholarship with a flair for communicating their
specialist knowledge to a wider,
non-specialist readership.

THE BRITISH MUSEUM

STOREHOUSE OF CIVILIZATIONS

JAMES HAMILTON

HEAD
of
ZEUS

An Apollo Book

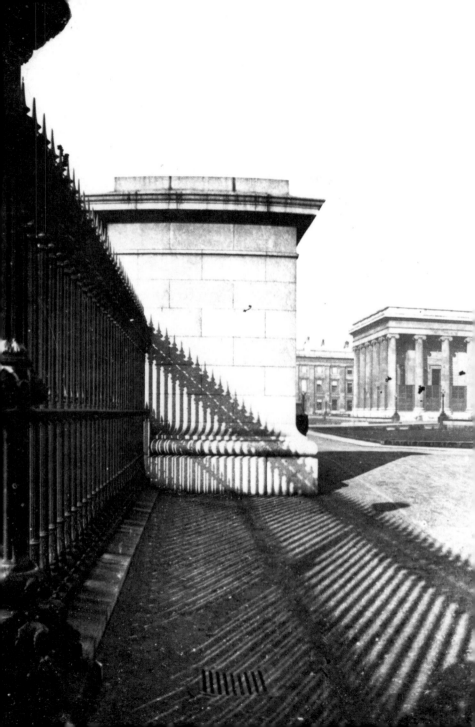

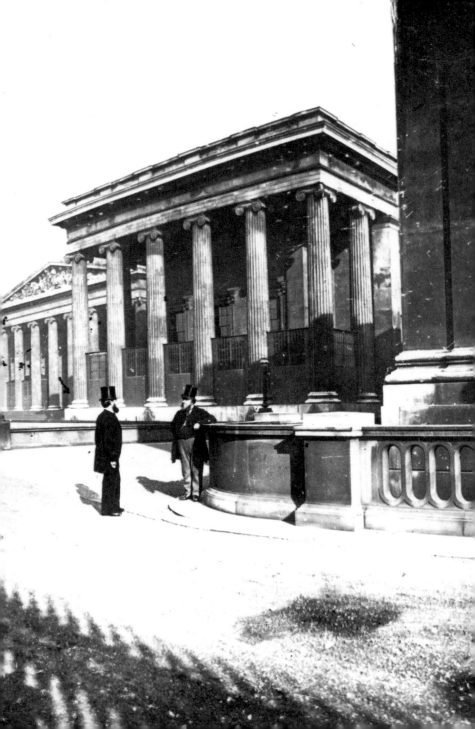

For Kate, my co-curator in all things

This is an Apollo book, first published
in the UK in 2018 by Head of Zeus Ltd

Copyright © James Hamilton 2018

The moral right of James Hamilton to be identified
as the author of this work has been asserted in
accordance with the Copyright, Designs and
Patents Act of 1988.

1 3 5 7 9 10 8 6 4 2

A CIP catalogue record for this book is available
from the British Library.

ISBN (HB) 9781786691835
 (E) 9781786691828

Designed by Isambard Thomas
Printed in Spain by Graficas Estella

Head of Zeus Ltd
First Floor East
5–8 Hardwick Street
London EC1R 4RG

WWW.HEADOFZEUS.COM

Prologue

abaeterno &usque inaeter-
num supt mentes eum
E trufticia illius infilios filio-
hif qfervant testamtu eius;
E tmemores sunt mandato-
ipsius ad faciendum ea

Dns incelo parauit sede suam:
& regnu ipsius omni dominabit;
Benedicite dno angeli eius
potentes uirtute facien-
tes uerbu illius ad audien-
da uoce sermonum eius;

Benedicite dno oms uirt
eius ministri eius qui
tis uoluntatem eiu
Benedicite dno oma opa
monm loco dominatio
ei benedic Anima mea

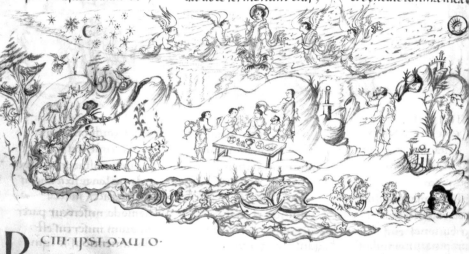

BENEDICANIMA
mea dno. dne ds meus
magnificatuf es uehementer;
Confessionem &decorem
induisti: amictus lumine
sicut uestimento
Extendens caelum sicut
pellem: qui tegis aquis
superiora eius
Qui ponis nubem ascensum

tuum: qui ambulas super
pennas uentorum
Qui facis angelos tuos spc
&ministros tuos ignem
urentem
Qui fundasti terram super
stabilitatem sua non incli-
nabitur inseclm saeculi;
Abyssus sicut uestimentu
Amictus eius sup montes

stabunt aquae
Ab increpatione tua fug-
ent: auoce tonitrui tu
formidabunt
Ascendunt montes & de
scendunt campi: inloc
quem fundasti eis
erminum posuisti quem
transgredientur neq; co
uertentur operire terra

The British Museum touches all parts. It entered my blood-stream when, as a young student reader in the early 1970s, I entered for the first time the narrow passage (now demolished) which linked the Museum's entrance hall with the Round Reading Room. I cannot remember what it was that I came to read, but it was nevertheless a kind of birth.

What I do vividly recall, however, are the rooms of the Department of Western Manuscripts, then to the right of the main entrance. There in 1970 I was allowed to handle and look at, on my own, the masterpiece of medieval illumination MS Harley 603, the Anglo-Saxon copy of the ninth-century Utrecht Psalter. Fired up by a talk given in Utrecht the previous year by the Princeton art historian Professor Rosalie Green, in the presence of the original Utrecht Psalter, I wrote to the British Museum to ask if I could look at Harley 603. They gave me a pair of white gloves, and rested the manuscript on a cushion in front of me. There must have been a curator hovering within sight, but I felt myself alone with this magnificent volume, turning its heavy pages freely, looking at the masses of ink-drawn figures that skittered here and there, interweaving themselves with the calligraphy. It was surprisingly well coloured, the figures energetic and liberally choreographed across the pages and among the paragraphs. They had expressive, even theatrical gestures; long, lanky bodies with, in many cases, hardly a trace of a neck. This privilege, to see and hold and turn these thousand-year-old pages, and be trusted to do so, was an illumination in itself, a doorway into a world that I had begun to experience through slides and books. Now, however, it was flooding towards me as proof of the uses of museums.

At around this same time I visited the Department of Prints and Drawings to look at watercolours by the eighteenth-century amateur Thomas Sunderland. They gave me the box, and I was happy. Further down the desk was the department's Keeper, Edward Croft-Murray, with his large and voluminous presence,

A page from Harley MS 603, *The Harley Psalter*, an eleventh-century Anglo-Saxon copy of *The Utrecht Psalter*, featuring Psalm 103, 'The creations of the Lord'.

going rapidly through another box, turning over mounted drawings, and talking grandly at the top of his penetrating voice about his life and times. That I found discomforting, but perhaps I should have listened to him more closely, as I wondered how museums should present themselves.

In 1972 I was one of the many thousands who queued to see the Tutankhamun exhibition, having in my case come up especially to London on the train from Derby. Long lines of patient people snaked up and down between the metal barriers set out on the forecourt, and we waited an hour or maybe two shuffling towards the steps. There was an ice-cream van with cornets for sale and a mobile café, but most memorable were the people standing quietly together: men in suits and bowler hats; students in jeans; families with children swinging on the barriers; and me.

At last I came face to face in the darkness of the exhibition with the boy King Tut himself. He was shining in reflected light, closely fitted into his glass case, a small tomb after his big sleep

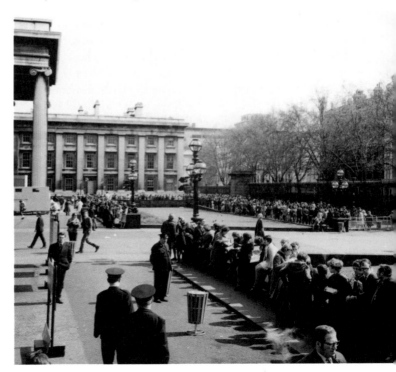

in his long tomb in the sand. He gazed out timelessly, as he had since his burial in the Valley of the Kings so many centuries ago; 3,000 years in the dark. The temporary exhibition floor creaked under the weight of his supplicants and admirers as I addressed him wordlessly, and moved on.

* * *

Museums do not just appear; like all other life forms, they evolve. Even a museum that might seem to have been ready made, such as the Wallace Collection in London, grew first as a private collection before it became, by the shifting plates of time, the nation's property.

The British Museum, described by Virginia Woolf as 'one solid immense mound, very pale, very sleek in the rain',[1] was once a more-or-less organized jumble stored in the large damp chambers of a crumbling London mansion, awaiting more and yet more cartloads to add to the pile. Initial attempts at order soon got out of hand, but it is very clear that from the start the curators of these various and varied collections had a strong sense of responsibility threatened only by lack of money and human frailty. It is the task of a museum, and the duty of its curators, to create order out of jumble, knowledge out of order, and, out of knowledge, an understanding of the world and of humanity's place within it. The British Museum is a shining example of the values of this practice.

Museums – and this includes art galleries which are a variant of the main form – are a high-water mark of civilization, a public manifestation of civic good that assumes that a knowledge of the past and an understanding of human aspiration and achievement is a prerequisite for good government. Once we start chipping away at our museums we are chipping away at civilization's point. How we got from a disorganized jumble to 'one solid immense mound' reflective of human aspiration is the burden of this story.

Queues waiting to go into the 1972 exhibition
The Treasures of Tutankhamen at the British Museum.

The Beginnings

*'I went to see
Dr Sloan's curiosities'*

The British Museum is the product of a very British piece of creative thinking. Rich and fascinating collections were of course held in other European nations, but these were largely in princely, ducal or ecclesiastical ownership, and where the public was admitted it was under strictly filtered conditions. None, in the mid-eighteenth century, was the property of the people. However, before the wars with France, before the French Revolution, before the 'loss' of America and eighty years before the Reform Act, things in Britain took an oddly British, even cautious, revolutionary path. The catalyst here was the reading of the humane and thoughtful will of Sir Hans Sloane, and a subsequent enlightened and pragmatic decision of Parliament.

Sir Hans Sloane, born in Killyleagh, Ireland, in 1660, made his fortune as a physician and an entrepreneur. His particular youthful interest in botany and natural sciences led him to study in London, Paris and Montpellier for a degree in medicine. Travel and medicine took him yet further, to Jamaica, as physician to its governor, the duke of Albemarle, and with time on his hands he was able to study Jamaican natural history, and in particular its plant life. The fruits of Sloane's studies included his discovery of the medicinal properties of quinine, and the improvement of a health-giving local drink made from cacao, whose recipes he collected, and in due course profited from as a patent-holder in milk chocolate. These were among the sources of Sloane's great wealth, along with property development and letting, and the slavery-derived income from the plantations his wife had inherited in the West Indies.

This passion for collecting and organizing, and Sloane's courageous embarkation on dangerous travel, expressed itself multifariously. One example is his two-volume account of his discoveries in and on the way to the West Indies, which he published in 1707 and 1725 as *A Voyage to the Islands Madera, Barbadoes, Nieves, St Christophers, and Jamaica; with the Natural*

Bust of Sir Hans Sloane, 1756, by Michael Rysbrack.

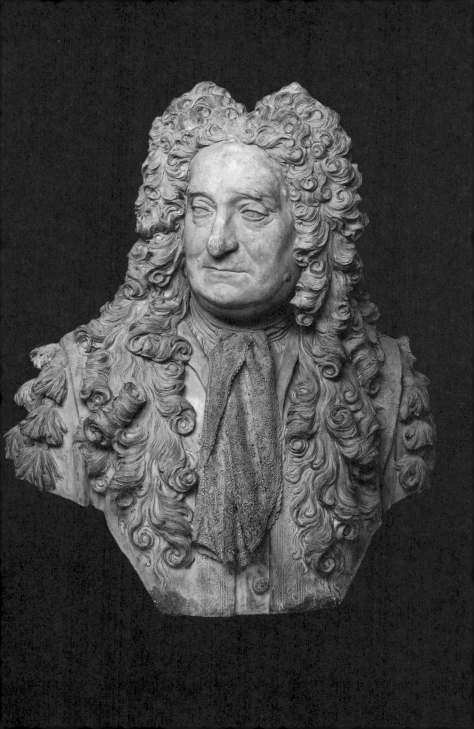

History of the Herbs and Trees, Four-Footed Beasts, Fishes, Birds, Insects, Reptiles, &c of the last of those Islands, to which is pre-fix'd, An Introduction, wherein is an Account of the Inhabitants, Air, Waters, Diseases, Trade &c of that place; with some Relations concerning the Neighbouring Continent, and Islands of America. Invocation of this book's long and intricate title, in which already so much of the natural world's interconnections are signalled, articulates Sloane's life ambitions, his omnivorous interests, and his understanding of the imperative of communication. In such fertile, well-endowed ground was the seed of the British Museum nurtured. That book title alone is a grand start to the genesis of a great museum, and the demands it would make in perpetuity on its curators and trustees.

Sloane's growing collections attracted the early interest of fellow intellectuals. The diarist John Evelyn visited him in 1691 and encouraged the then thirty-one-year-old to write *Voyage to the Islands*:

> I went to see Dr Sloan's Curiosities, being an universal collection of the natural productions of Jamaica, consisting of Plants, fruits, Coralls, Minerals, stones, Earth, shells, animals, insects &c:, collected with greate judgement, several folios of Dried plants & one which had about 80: several sorts of Fernes, & another of Grasses; &c: the Jamaica pepper in branch, leaves, flowers, fruit &c. which with his Journal, & other Philosophical & natural discourses & observations is indeede very extraordinary and copious, sufficient to furnish an excellent History of that Iland, to which I encouraged him, & exceedingly approved his Industry.[1]

Sloane's sense of order and completeness was apparent from the start. When the German scholar and traveller Zacharias von Uffenbach visited in 1710 he was shown round the collection by Sloane, and noted that an hour of his time as a physician was worth a guinea: 'We thought, indeed, that he did us a very great

honour by sparing us the time between half past two & seven o'clock. Being a much-travelled man he is vastly aimiable, & especial to Germans & such persons as have some knowledge of his treasures.'[2]

The collection was first held in Sloane's house in Bloomsbury – not so many yards from where much of it is now – before being moved in 1742 to Chelsea Manor. Sloane's servant Edmund Howard described how 42,000 volumes were sent 'loose in carts and tossed from the cart to a man on a ladder, who tossed them in at a window, up one pair of stairs, to a man who caught them as men do bricks.'[3] Thus were libraries moved in the eighteenth century.

It comes as little surprise, therefore, to read an account in the *London Magazine* of a visit to Chelsea Manor by Frederick, Prince of Wales, and his wife Augusta in 1748. This vast, rambling set of buildings overlooking the river was, five years before Sloane's death, already a treasure palace of his collection of the world's wonders:

> [In] the gallery 110 feet in length... the most beautiful corals, crystals and figured stones; the most brilliant butterflies and other insects; shells painted with as great a variety as the precious stones, and feathers of birds vying with gems... Then a noble vista presented itself thro' several rooms filled with books; among these many hundreds of volumes of dried plants; a room full of choice and valuable manuscripts... Below stairs some rooms are fitted with the curious and venerable antiquities of Egypt, Greece, Hetruria [*sic*], Rome, Britain, and even America... The halls are adorned with the horns of divers creatures.[4]

The royal visit was the crowning act of a process of diplomatic and political pressure which had been intermittently and sometimes half-heartedly applied to encourage the preservation and public ownership of Sloane's collection. Sloane had made his will nine years earlier (see Appendices 1 and 3), and in it desired that

OVERLEAF
A Plan of the Cities of London and Westminster, 1746, by John Rocque. Montagu House is northeast of the intersection of Oxford Street and Tottenham Court Road in the top left corner.

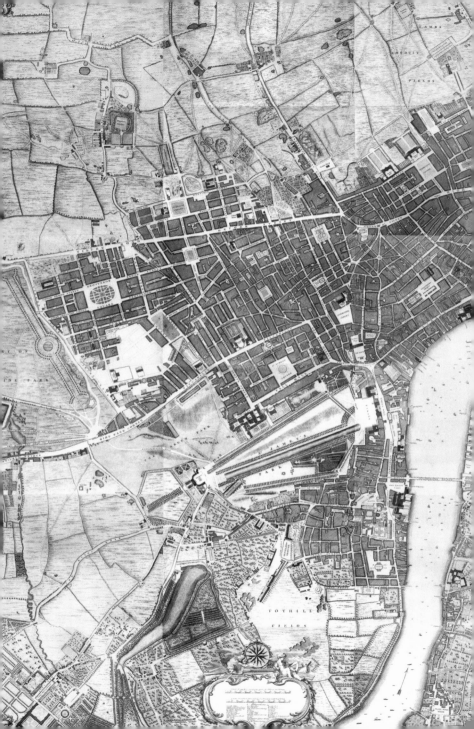

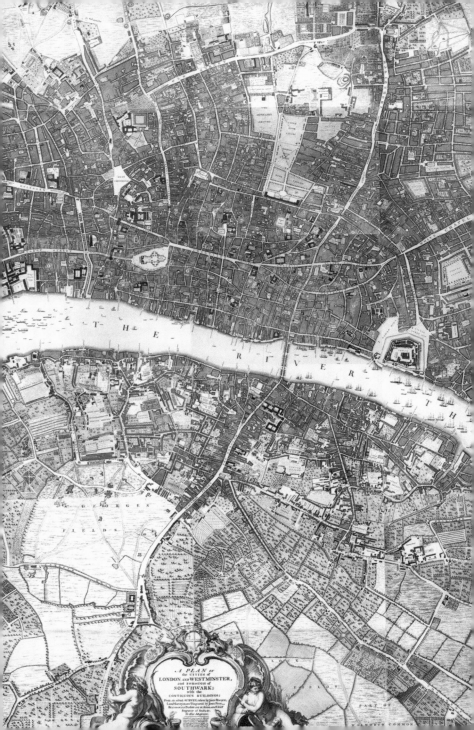

THE — RIVER — TH

S.T GEORGES

FIELDS

A PLAN of
the CITIES of
LONDON AND WESTMINSTER,
and BOROUGH of
SOUTHWARK;
with the
CONTIGUOUS BUILDINGS;
From an actual SURVEY, taken by John Rocque,
Land Surveyor, and Engraved by John Pine,
Bluemantle Pursuivant at Arms, and Chief
Engraver of Seals, &c. To His Majesty.

PART OF

H. CLWORTH COMMON

the collection be offered to the king for £20,000, and, if the king declined to accept it, be offered one by one to the Royal Society, the University of Oxford, the Edinburgh College of Physicians, and then on refusal, in descending order, to the Royal Academies of Science in Paris, St Petersburg, Berlin and Madrid. In the event of refusal it was to be sold piecemeal. Nowhere does Sloane offer it to the British Parliament.

The cultured and thoughtful prince, the eldest son of George II who died before he could become king, said exactly the right thing:

> [The Prince of Wales] expressed the great pleasure it gave him to see so magnificent a collection in England, esteeming it an ornament to the nation; and his sentiments, how much it must conduce to the benefit of Learning, and how great an honour will redound to Britain to have it established for publick use to the latest posterity.[5]

This opinion, and certainly conversation with others, and his own ruminations among his butterflies, antiquities and gems, may have led Sloane to consider a more radical solution, which, through a codicil of 10 July 1749, enabled the collection to be established for public use, and thus to lay the foundations of what became the British Museum. Sloane's thought evolved; he listened to advice from such as the Royal Society and the Society of Antiquaries; he changed his mind.

The codicil changed everything. Sloane specified by name forty-eight individual trustees, and then thirty-four officers of state, from the king down, and peers of the realm, to be responsible for his collection, 'which consists of too great a variety to be particularly described' (see Appendix 4). Anybody who was anybody was on Sloane's list; if you were a grandee and you were not on it you could be mighty peeved. Sloane then became specific:

Frederick, Prince of Wales, 1735–6, by Jacopo Amigoni.
He is holding a copy of Pope's translation of Homer.

But I mean all my library of books, drawings, manuscripts, prints, medals and coins, ancient and modern, antiquities, seals &c, cameos and intaglios &c, precious stones, agates, jaspers &c, vessels &c of agate, jasper &c, crystals, mathematical instruments, drawings and pictures, and all other things in my said collection or museum, which are more particularly described, mentioned and numbered, with short histories or accounts of them, with proper references in certain catalogues by me made, containing thirty-eight volumes in folio, and eight volumes in quarto, except such framed pictures as are not marked with the word 'collection' to have and to hold to them and their successors and assigns for ever.

Then he added his killer demand:

And I do hereby declare… that my said museum or collection… may be, from time to time, visited and seen by all persons desirous of seeing and viewing the same… that the same may be rendered as useful as possible, as well towards satisfying the desire of the curious, as for the improvement, knowledge and information of all persons.

This gave no means of escape or quibble for the forty-eight plus thirty-four hostages. Sloane tied them down finally by adding that they must be active and diligent visitors to the collection 'to peruse, supervise and examine the same and the management thereof; and to visit, correct and reform from time to time as there may be occasion'. He also insisted that they apply to the king or Parliament for £20,000 to pay to his surviving family – he cannily added that the collection was worth at least four times as much. The trustees – and here he allowed them to reduce themselves to a core six or ten – would be obliged to meet regularly and establish 'statutes, rules, and ordinances, and to make and appoint such officers and servants for the attending, managing, preserving and continuing of my said museum, or collection and premises, for ever, with such salaries, payments, or allowances to them respec-

tively, as shall seem meet and necessary'. This, Sloane believed, would preserve and continue 'my said collection or museum in such a manner as they shall think most likely to answer the public benefit by me intended'.

Other interests were now also beginning to come into play. The family of the antiquarian and politician Sir Robert Cotton (1571–1631) had for decades been concerned about the state of the unique and vitally important collection of pre-Reformation manuscripts, state papers and antiquities languishing in Cotton House, beside the Palace of Westminster. Louis XIV had offered £60,000 for them, with a French title for Cotton's grandson thrown in. Among the manuscripts were the eighth-century *Beowulf*, the Lindisfarne Gospels and two of the four copies of Magna Carta. Sir Christopher Wren, commissioned to design a new library at Westminster, had warned Lord Godolphin, the lord high treasurer, that the room where the collection was kept in Cotton House was 'in so ruinous a condition that it cannot be put into a substantial repair'.[6] A fire in 1731 caused the destruction and damage of some of the manuscripts, and also drew the attention of Arthur Edwards (d.1748), an officer in the Horse Guards, who owned a library of 2,000 English, French and Italian books. These he offered to the Cotton heirs, with £7,000 to build a new library to hold both the Cotton and the Edwards libraries in perpetuity: 'such a House as may be most likely to preserve that Library as much as can be from all Accidents'.[7] Sloane was well aware of the deterioration of the Cotton manuscripts, and was not going to let that happen to his collection.

In December 1748, a third element in this intricately patterned tapestry revealed itself. The duchess of Portland, Margaret Cavendish Bentinck, Lady Harley, was advised that the library of about 8,000 volumes that had been collected by her grandfather and father, Robert and Edward Harley, earls of Oxford, was suffering in damp rooms in Dover Street, in Mayfair. On the lower shelves

of most of the ninety-seven bookcases the books were found to be 'mouldy at the bottom'.

By the early 1750s the future of the Sloane, Cotton and Harley collections was critical, and at the highest level was known to be so. The Edwards library, often overlooked, was another looking for a home. The prospect to officialdom of losing one collection might have been bearable; two perhaps was just tolerable; three unthinkable; but four impossible to contemplate, and so the state tied them all together, used one problem to solve another, and swung into action. Sloane had bound and gagged the British state.

On Sloane's death on 11 January 1753 the active trustees came up with the following statement of intent for the nation, to be bolstered by an act of Parliament. This received royal assent on 7 June, just under six months after Sloane's death:

> An Act for the Purchase of the Museum or Collection of Sir *Hans Sloane* and of the *Harleian* Collection of Manuscripts, and for providing One General Repository for the better Reception and more convenient Use of the said Collections, and of the *Cottonian* Library and of the Additions thereto.[8]

The act neatly collared the entire Sloane, Harley, Cotton and Edwards collections, and most importantly allowed for future expansion – 'Additions thereto'. At a stroke, the nation had acquired huge swathes of its own back catalogue, regal, political, ecclesiastical, literary and historical, all rescued from rot and rodents in the nick of time.

Parliament had no choice but to grant £20,000 'of lawful Money of Great Britain' to the project, but that was misleading: this was not government money, but cash to be raised by lottery and paid to Sloane's family as a nominal sum 'in Consideration of & in full Satisfaction for' the collection and for the use for the time being of Sloane's 'Manor House and Garden, with their Appurte-

nances, and… Water, until a more convenient Repository, more durable and more safe from Fire, and nearer to the chief Places of public Resort, shall be provided for the Reception of the said Museum or Collection'.

Thus, through Sloane's desire and parliamentary action, ownership of the collections was vested in a trust, whose duty was to preserve, increase, display, enable study, explain, and hand on to posterity. In effect, nobody owned the collection but everybody did. Now Parliament was poised to take over. Sloane's trustees had to dissolve themselves so that three estates of the realm could move in, the church, the law and the commons, specifically excluding the crown. Thus the three leading trustees of the British Museum were the archbishop of Canterbury, the lord chancellor, and the speaker of the House of Commons. There were a further seventeen working official trustees, principally the chancellor of the exchequer and lord chief justice, with the Sloane, Cotton and Harley families being represented by two trustees each. This category, family trustees, became standard for the British Museum as further large private collections were added. It is fair to say that from the start the British Museum accrued a heavy burden of bureaucracy.

Three 'fundamental principles' for managing the collection guided Sloane's original trustees, and still do for the British Museum as a whole:

1 That the collection be preserved intire without the least diminution or separation;

2 That the same be kept for the use and benefit of the publick, who may have free Access to view and peruse the same, at all stated and convenient seasons agreeably to the Will and intentions of the Testator, and under such restrictions as the Parliament shall think fit.

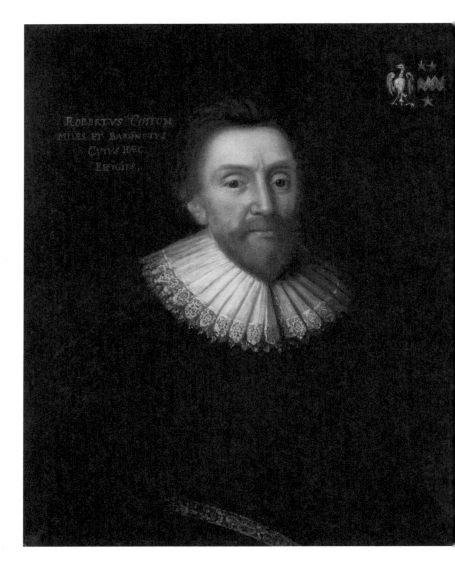

Sir Robert Bruce Cotton, 1629, by Cornelius Johnson.

These are universal requirements. The third was soon discharged:

> 3 That in case it should hereafter be judged the most beneficial
> and advantageous for the publick use, to remove the collection
> from the manor house at Chelsea, where the same is now
> deposited, that it be placed properly in the Cities of London or
> Westminster or the suburbs thereof.[9]

Such will and administrative energy gave particular pleasure to the duchess of Portland, concerned as she was with the future of the Harley collection. She told the speaker of the House of Commons: 'your idea is so right & so agreeable to what I know was my Father's intention that I have a particular satisfaction in contributing all I can to facilitate the success of it.'[10] The value of the duchess of Portland as the British Museum's midwife was incalculable. She was one of the toughest, cleverest, and best-connected women of her day, not only in control of estates and a fortune, but an important collector of natural history material, and an influential and powerful figure in the great world. As a child she had been brought up following the principles of John Locke.[11] With this particular duchess on board the trustees' job would be practically done for them.

Thus the British Museum's foundations were laid in law and attitude, fully compliant with Sloane's will, which stressed his desire that his collection may be of 'benefit to mankind, may remain together and not be separated… where they may by the greatest confluence of people be of most use… towards satisfying the desire of the curious, as for the improvement of knowledge and information of all persons'. As Sloane had written elsewhere: 'The more any man searches the more he will admire.'

The British Museum in the Eighteenth Century

'The rooms so numerous'

Having secured the Sloane, Harley, Cotton and Edwards collections, the trustees' next task was to find a 'general Repository' for it all. They considered, but rejected on account of cost and 'inconvenience of situation, and other circumstances', the offer of Buckingham House – later developed into Buckingham Palace – and eventually settled on the empty and crumbling Montagu House in Bloomsbury. This seventeenth-century French-style chateau, conveniently between the Cities of London and Westminster, had long been abandoned by the duke of Montagu and was in a sorry state. It had already been rejected as a home for the Foundling Hospital* on account of its poor drainage, but nevertheless for a museum – a new kind of institution for which few building precedents existed – it seemed in 1753 to be ideal.

Montagu House required urgent repairs: 'the lower part of the roof with the Gutters and the Cornices [are] in a bad condition, and executed in so improper a manner as to be always liable to decay if reinstated in the former method.'[1] The more expensive proposal to use stone, rather than the original wood, was immediately accepted. The building also needed extensive new bookcases to house the bound volumes: a surveyor's report of July 1755 advised the installation of 8,160 feet (2,490 m) of new shelving immediately. Green flock wallpaper was chosen, and became 'general in all the rooms'.[2] So work progressed, with a will and a budget, and across the years 1754 to 1758 Montagu House was gradually brought up to contemporary standard as the collections arrived by the cartload at Great Russell Street from Chelsea Manor, Dover Street and Cotton House, Westminster. In 1757 these collections were joined by a gift from George II of the old Royal Library of the Sovereigns of England, which

* The orphanage, initially in Hatton Garden, later in Bloomsbury, founded by Captain Thomas Coram in 1739 for 'the education and maintenance of exposed and deserted young children' in London.

included such treasures as the *Codex Alexandrinus* and Matthew Paris's *Historia Anglorum*, along with the king's prerogative of the copyright deposit of every book published in Britain.

The gardens of Montagu House were promptly tidied up. Bloomsbury was a fashionable quarter, and from 1757 people were allowed to walk at ease in the gardens. As the map on pp. 20–1 shows, the gardens backed on to wide open fields, stretching out to Hampstead and Islington. It was possible to get a quick preview of what was going on inside, if you knew who to ask. The poet Catherine Talbot (1721–70) wrote about an evening in 1756 that she had spent in Montagu House:

> Henceforth to be known by the name of the British Museum. I was delighted to see Science in this Town so Magnificently & Elegantly lodged... [I] thought I liked [Montagu House] much better now, inhabited by valuable Mss, Silent Pictures, & Ancient Mummies, than I should have done when it was filled with Miserable Fine People, a Seat of Gayety on the inside, & a place of Duels without... Nothing is yet ranged but two of three rooms of Mss. Three and Thirty Rooms in all are to be filled with Curiosities of every kind.[3]

On 15 January 1759 the British Museum opened to the public. Easy to overlook is the revolutionary nature of its name, and why from the highest echelons it was known immediately and indelibly as the *British* Museum. The Act of Union to unite the English and Scottish nations had been ratified just fifty-two years earlier in 1707, and Britain was an entity in its infancy. Thus the conception of the 'British' Museum affirms a commitment by the British state, through Parliament, to embrace a united future between England and Scotland by means of an organization whose task it is to preserve, present and study the roots and products that nurture and support it. The Museum might have been named after its principal initial benefactor, Sir Hans Sloane,

OVERLEAF
An engraving of the south front and courtyard of Montagu House, Great Russell Street, by Sutton Nicholls, from *Stow's Survey of London*, 1728.

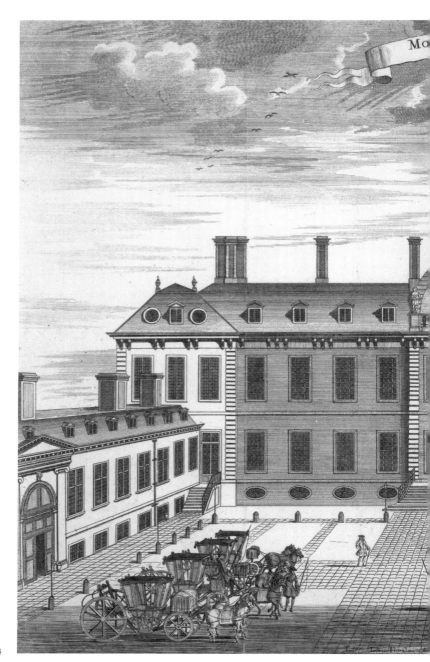

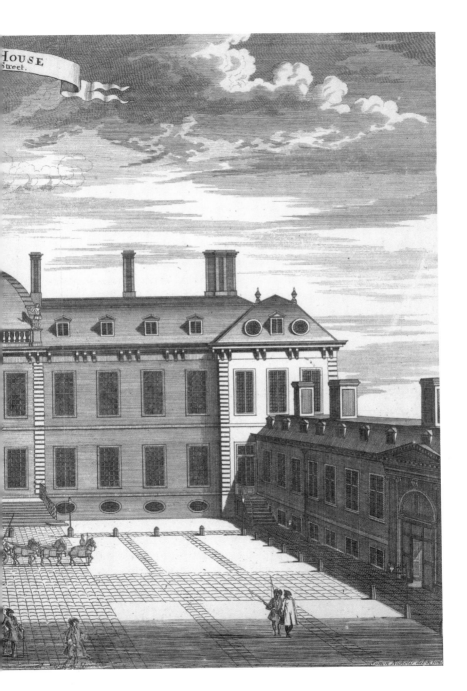

and thus become 'The Sloanean Museum', following the way the Ashmolean in Oxford is named. Sloane was, however, only *primus inter pares*: the collections of Harley, Cotton, Edwards and the Royal Library also had critical roles in its foundation, so if ever proposed 'The Sloanean' would have been immediately exclusive and inadequate. Deference to the crown might have led some to advocate 'The Royal Museum' as its title, though the influence of Parliament certainly gave that idea, if it was ever uttered, a still birth. 'Natural History Museum' or 'Antiquities Museum' would cover only a fraction of the museum's remit. Sloane's will demanded that his collection be preserved in London 'entire without the least diminution or separation... for the use and benefit of the public... to have and to hold to them and their successors and assigns for ever'. This conscious echo of the Anglican marriage service required mutual responsibility between government and public, and a universalist approach. Thus the trustees chose 'The British Museum', a name enshrined, from the first day, in The British Museum Act (1753), 26 George II Chapter 22. As a name it has, almost uniquely in the evolution of British bureaucratic nomenclature, survived unchanged and unchallenged, as proud and secure as the Museum's columned portico. Like the portico, it is recognized and respected the world over. It does not chase after the fashionable reductionism that led the Tate Galleries to become 'Tate' in 2000, or to prompt so many of the great city art galleries and museums in Britain to drop 'City' from their titles.

To get into the British Museum, to see the exhibits, people had to apply in writing in advance to get one of the handful of tickets issued for each day – first it was ten, later increased to twenty-five. So while the trustees insisted that the Museum was 'for the use and benefit of the public', it was initially a very narrow public indeed, and *ipso facto* only those who were 'studious and curious persons', literate and motivated enough to be able to write and ask, and (a later stipulation) who were 'of decent appearance'.

The British Museum was headed by a Principal Librarian, Gowin Knight (1713–72), an inevitable circumstance on account of the predominance of books in the early collections; the profession of curator did not, in the 1750s, exist. Unique to the British Museum, the post of Principal Librarian was appointed by the crown. There would have been no fanfare, no media-wide press coverage, no parties or glitzy private views, as is always the case when a new museum opens today. The museum claimed to be open 'every day', 9 a.m. to 3 p.m. in winter, extended to 4 p.m. in summer. 'Every day' was indeed the case if you excluded Saturdays and Sundays, Christmas week, Good Friday and Easter week, Whitsun and the week following, and all official and ecclesiastical thanksgiving and fasting days, as well as the whole of August and September when it was closed. However, 'to accommodate for a few months persons of a lower class', there was in due course late opening 4 p.m. to 8 p.m. on Mondays and Fridays. These hours can only have been in the summer when days are longer, though not of course in August and September. In sum, the British Museum was open just a tiny bit – for about 170 of the 365 days available in the year – but it was at least a start.

In a letter of application the prospective visitor had to state his or her name, address, 'condition', the desired date and time of admission, and hand it to the porter before 9 a.m. or between 4 p.m. and 8 p.m. at the lodge in the forbidding wall along Great Russell Street on a preceding day. Names went into a register that Gowin Knight would look over, and if he said yes you (or your servant) would have to go back to Great Russell Street, collect the ticket, and prepare to turn up at the appointed time. You would have to join a party of between four and ten, and be guided briskly from room to room. There were five such tours a day – no children – and no time was given to stand and stare: the ticket entitled merely 'a *sight* of the British Museum'. The tours were free of charge, and tipping was banned on pain of the guide's dismissal.

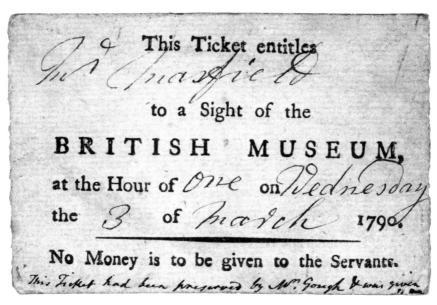

This Ticket entitles

Sir Chasfield

to a Sight of the

BRITISH MUSEUM,

at the Hour of *One* on *Wednesday*
the *3* of *March* 1790.

No Money is to be given to the Servants.

This Ticket had been preserved by Mrs. Gough & was given

A visitor's entry ticket to the British Museum, 1790.

While these highly restricted hours and arrangements seem
ludicrous now, we should remember that society was, in 1759,
just beginning to explore the novel idea of public museums. This
was a brave social and educational experiment, one that had been
pioneered in Oxford by the Ashmolean Museum, the only insti-
tution that might then have been seen as a rival to the British
Museum.* In London it had been preceded only very recently by
the innovation of the Foundling Hospital where works of art were

* The Ashmolean Museum was opened in Broad Street, Oxford, in 1683, in a
building constructed to hold, display and study the collections. It had a chemical
laboratory in the basement. The building now houses the Oxford University
Museum of the History of Science.

publicly displayed, but that was very small beer by comparison. A further equivalent in Britain were those grand houses whose owners permitted visitors, and churches where, since the destructions of the Civil War a hundred years earlier, works of art, votive objects, texts, symbols and decorations were creeping back. In London there were occasional private collections such as the one that the naturalist Gilbert White described as 'the curious exhibition of stuffed birds at Spring Gardens'.[4] To many in the eighteenth century the word 'museum' might merely conjure up what White called 'the countryman's museum', a barn door where farmers nailed dead birds to frighten predators.

The men who ran the British Museum in the late eighteenth century – it was only men at this time – were beginning to evolve their profession out of the generation of dilettanti gentlemen trained in professions such as medicine, the law or the church, and whose interest was guided by the engagements of the Royal Society, the Society of Antiquaries and the Society of Arts. These organizations, and their ambitions for learning and exchange between scholars, were as essential a foundation of the British Museum as were its first collections, Sloane, Cotton, Harley, Edwards and the Royal Library. Gowin Knight was a physician and a pioneer of the understanding and uses of magnetism. He was a Fellow of the Royal Society, and contributed to the development of his branch of natural philosophy through papers published by the Society, and to the security of commerce through improving magnets in ships' compasses. When appointed to his post in 1756 he had no apparent experience as a librarian, or as what we would now call a curator. He lived in the building as caretaker of the collections, continuing until his death, and was the principal servant of the trustees. It was under Knight's direction and authority that the early displays took the form they did. Among his early colleagues were the numismatist and serving Baptist minister Andrew Gifford (1700–84), a Fellow of

the Society of Antiquaries; Matthew Maty (1718–76), a physician who eventually died 'in narrow circumstances' in the Museum; Andrew Planta (1717–73) a mathematician and minister of the German Reformed Church, whose son Joseph would follow him into the Museum; Charles Morton (1716–99), another physician; and James Empson (d.1765) who had looked after Sloane's collection during its owner's lifetime. It was also these men who, turn by turn, escorted visitors through the Museum's rooms, each one no doubt in his own style and at his own chosen speed.

The British Museum reached towards the ideal of a physical, social and administrative expression of the beginnings of the Enlightenment, embracing the entire nation from the king down. A movement that exalted reason as the primary source of intellectual authority, the Enlightenment spread across Europe during the eighteenth century. In France it manifested itself in the philosophical writings of Rousseau and Montesquieu, and in the *Encyclopédie*, twenty-eight volumes with illustrations, edited by Diderot and d'Alembert, whose aim was to contain all human knowledge to date. In Scotland it created Edinburgh's New Town and the work of the economist Adam Smith and the philosopher David Hume; in Sweden it was expressed in the taxonomy of Carl Linnaeus; in England it was typified by the humane philosophy of John Locke, Samuel Johnson's *Dictionary* – and the British Museum. Here, the essence of the learning found on the Grand Tour for the wealthy could be distilled for all. The Enlightenment embraced notions of order and organization, as well as the pursuit of rational understanding. These aims and principles were set within the bedrock of the Museum from the outset.

However, the Enlightenment, with the light of reason shining through its columned portico, cannot be regarded as the British Museum's sole wellspring. There were other ideas in the mix. The Museum's founders came from an earlier generation for whom the empirical philosophy of Sir Francis Bacon (1561–1626) was

the guiding intellectual light. Bacon advocated scientific experiment to forward understanding, as did the Fellows of the Royal Society, and it was the pursuit of a Baconian spirit of enquiry that required the Ashmolean Museum to have a chemical laboratory in its basement. No such facility was installed in Montagu House, and from this we might conclude that the British Museum and the Ashmolean, while sharing their beginnings, chose different paths to travel. One became the encyclopaedia, the other the laboratory.

The quick-step of parties of five or more through the rooms of Montagu House in 1759, passing shelves of books and manuscripts at speed, cases of coins and medals, and trays of glittering minerals with stuffed fish and elk horns on the side, might not appear to constitute a critical contribution to an intellectual movement that was sweeping Europe, but it gradually had its cumulative effect. More immediately purposeful, however, was the opening of the Reading Room, at first in the northwest corner of the ground floor, in due course to expand into the floor above. It was much harder to get permission to read than it was to tour the Museum: readers were admitted by personal recommendation 'from some person of known and approved character as it might be dangerous, in so populous a metropolis as London, to admit perfect strangers'. An early reader was the poet Thomas Gray (1716–71). The Museum, he wrote:

> Is my favourite domain, where I often pass four hours in the day
> in the stillness and solitude of the reading room, which is
> uninterrupted by anything but Dr Stukeley the antiquary, who
> comes there to talk nonsense, and Coffee-house news; the rest
> of the learned are (I suppose) in the country, at least none of
> them come here, except two Prussians, and a man who writes
> for Lord Royston.

Gray adds an observation that indicates that beneath the apparent calm of the Reading Room lay wells of turbulent emotion. The

Vterpendragon

Æthelbertus

Arthurus

Sčs Oswaldus

British Museum did not sail on a sea of calm:

> When I call it peaceful, you are to understand it is only of us
> visitors, for the society itself, Trustees, and all, are up in arms,
> like the fellows of a college. The keepers have broke off all
> intercourse with one another, and only lower a silent defiance as
> they pass by. Dr Knight has wall'd up the passage to the little
> house, because some of the rest were obliged to pass by one of
> his windows in the way to it. Moreover the trustees lay out £500
> a year more than their income; so you may expect all the books
> and the crocodiles will soon be put up to auction, the University
> (we hope) will buy.[5]

The early generations of British Museum Librarians saw the
Reading Room as the Museum's heart, even its *raison d'être*. 'The
chief use of the Museum', claimed the first edition of the official
museum guide known as the *Synopsis*, published in 1808:

> Consists, no doubt, in the means it affords to men of letters and
> artists to recur [*sic*] to such materials as they may want in the
> prosecution of their studies or labours. [The Reading Room is
> set aside for]... closer inspection than can be had in the cursory
> manner allowed to ordinary visitors.

Everybody else would just have to put up with the inferior busi-
ness of viewing the exhibits, described by the *Synopsis* as 'a popu-
lar, though far less useful application of the Institution'.

* * *

As a preliminary to creating essential order within its walls, the
Museum had itself to be ordered into departments. The librari-
an-curators, 'a sensible and learned set of men, all equal to the
employment', began to be appointed in 1756, and had three years
to sort themselves and the objects out. Apart from repairing
Montagu House, the most urgent task was the construction of

Arthur And Other Early English Kings, 1255,
from Matthew Paris's 'Epitome of Chronicles'.

the yards and yards of bookshelves and the display cases. These were great days for carpenters. The entire first floor, of twelve linked rooms, was given over to printed books. The effect of this floor, therefore, was not of a museum, but of a library, the spines of countless volumes, row upon row. 'Strangers [i.e. visitors] are not conducted through these apartments, as the mere sight of the outside of books cannot convey either instruction or amusement': that was the contention expressed in the Museum's *Synopsis*.

However, the *Synopsis* was not the first published guide to the Museum. This was an anonymous pocket guide (1760), followed a year later by Edmund Powlett's independent, entrepreneurial, detailed overview of the contents of Montagu House: *The General Contents of the British Museum: with Remarks Serving as a Directory in Viewing that Noble Cabinet*. Powlett was modest in his claim: 'The Purchasers of this little Work must not expect too much,' he wrote, 'it not being meant to give a particular Account of all the Contents of this noble Cabinet: That is reserved for other Pens, being, as I am informed, to be published by the Officers of the House at a proper Time.'

He was being optimistic. It would be many years before even the *Synopsis* appeared, let alone the encyclopaedic works that Powlett anticipated. Powlett had himself been a museum visitor, and in writing his book, 'conveniently portable in the Pocket', he was responding to visitor needs:

> The Time allowed to view it was so short and the Rooms
> so numerous, that it was impossible, without some kind of
> Directory, to form a proper Idea of the Particulars: And though
> I was far from being unacquainted with most of the Contents
> before they became the Property of the Public, must confess
> myself to have been at some loss in this Respect.

It is notable that Powlett still refers to the British Museum as a 'noble Cabinet', an indication of the novelty of the idea of museum

contents being 'the property of the public', rather than the tightly cased and protected possessions of a wealthy or titled individual.

In the beginning the departments were three. Powlett gives these as Manuscripts, Medals and Coins; Natural and Artificial Productions; and Printed Books. This was an extremely rough and ready division, and it is significant that Coins and Medals went with Manuscripts rather than with Productions on account of their definitive stature. In addition there were 'many articles in the Hall, in the first Room above Stairs, which are not comprehended in any Department'. These included heavy stone objects, such as basalt columns from the Giant's Causeway in Ireland, a large cube of lava from Vesuvius, 'a fine Skeleton of a Unicorn Fish', a narwhal, and the head of a buffalo. Each department had its 'Under Librarian', serving Gowin Knight. There was also by 1761 what would now be called a New Acquisitions Room, referred to by Powlett as 'a Room... set apart for the immediate Reception of Presents': an Egyptian mummy, 'several large Corals' and 'a very fine Wasp's Nest'. The tour of the Museum that Powlett describes whisked each lucky group of people from basalt to mummy to manuscript to wasps' nest to sea egg to limpet shell, as if they themselves were ants in a rich man's cabinet. The first illustrated companion to the Museum was the folio edition *Museum Britannicum* furnished with engravings by John and Andrew Van Rymsdyk in 1778. This is prefaced by the words 'Follow nature!', the advice given to Cicero when he consulted the Roman Oracle on how he should live his life.

The experience of visitors is contradictory. Thomas Gray relished the slumberous silence of the Reading Room. P. J. Grosely, a visitor from France in 1765, wrote of 'the largest, the most stately, the best arranged, and most richly decorated' buildings of its kind, with courteous and obliging staff. However, the antiquarian William Hutton, coming from Birmingham in 1784, had a different experience. He was shown round at speed by a 'tall genteel

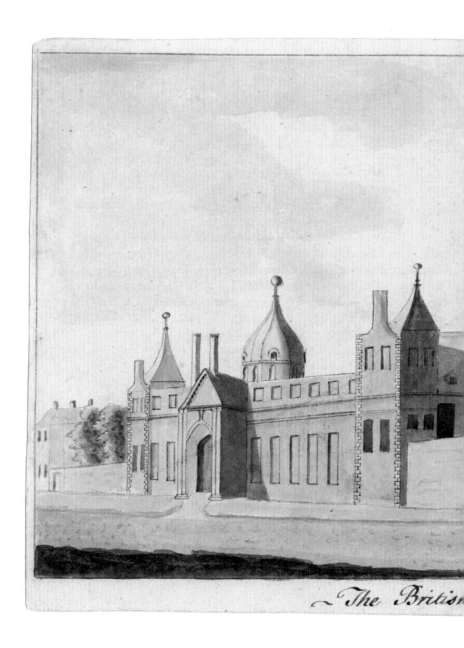

The Britis

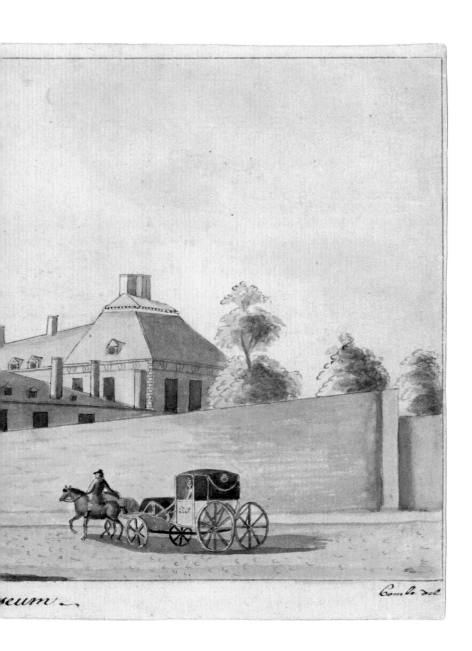

eum.

Comte del.

young man' in a party which seemed cowed into silence by the occasion:

> No voice was heard but in whispers. If a man spends two minutes in a room, in which are a thousand things to demand his attention, he cannot find time to bestow on them a glance a piece… It grieved me to think how much I lost for want of a little information. In about thirty minutes we finished our silent journey through this princely mansion, which would well have taken thirty days. I went out much about as wise as I went in.[6]

Tobias Smollett (1721–71) appears to have written the earliest fiction that embraced the British Museum, having his character Humphry Clinker expatiate on the manner of the earliest displays in Montagu House in the eponymous novel of 1771. These may have been Smollett's own considered views:

> Yes, Doctor, I have seen the British Museum; which is a noble collection, and even stupendous, if we consider it was made by a private man, a physician, who was obliged to make his own fortune at the same time: but great as the collection is, it would appear more striking if it was arranged in one spacious salon, instead of being divided into different apartments, which it does not entirely fill.[7]

Smollett's observation has the ring of truth, and one senses a contradiction here between his view that the rooms are not entirely full, and the reports of others that the place was over-stuffed at an early date. It is probable that this is a matter of perception, and that both views are correct, the tidal flow of material leaving some displays fuller than others. Jane Austen, born sixteen years after the Museum opened its doors, might have enticed a character or two into Montagu House, but seems not to have done so.

At the very beginning the British Museum did not intend to be a history of anything, but an encyclopaedia of things where

knowledge about discrete areas of human interest would grow. Arrangement into departments reflects this ambition. Thus the Museum was not to be like an art gallery where the history of art can be laid out, nor an exercise in social history where the threads of human lives are woven into a tapestry, but a vast book whose pages can be isolated, identified, interlinked and ordered. Nevertheless, as long as visitors were whisked round at speed, and until they were allowed to stop and look and think, it would remain that which it had hoped to avoid, a muddled Cabinet of Curiosities.

Running the Museum in the Early Nineteenth Century

*'The Trustees shall have
full power at all times'*

Museums are institutions of suction, drawing stuff towards them from every part of life: from the Parthenon Sculptures to a vase found in an attic. The early decades of the British Museum, once it was open and running, saw its suction effect coming powerfully into play.

Nevertheless change within the Museum to accommodate the new worlds signalled by these objects was very slow indeed. Captain Cook and his accompanying naturalists Joseph Banks (1743–1820), already a young and diligent inhabitant of the Reading Room, and the Swede Daniel Solander (1733–82), an assistant in the Department of Natural and Artificial Productions, returned home in 1771 from the South Seas. They brought with them a new, exotic kind of curiosity, a world away from Sloane's butterfly collection or Cotton's Lindisfarne Gospels. Emerging from below decks of HM Bark *Endeavour* were beads from Tahiti, weapons from New Zealand and clothing from Australia. From the North Pacific, material was also donated from the finds of the explorer Captain George Vancouver. While the Sloane collection already included an Akan drum from West Africa, acquired in Virginia where it had been brought on a slave ship, the objects collected on the Cook and Vancouver voyages set the ethnographical collections on a new journey that severely challenged the Museum's principle of retention, as descended from Sloane. There was simply too much stuff to cope with.

While much of Cook's material was sucked in, large unregistered quantities were ejected, removed, bartered or otherwise given away, and disappeared due to lack of curatorial care or interest. What Cook described as 'a collection of artificial curiosities from the South Sea islands',[1] augmented by Vancouver's material, had by 1816 been consolidated into fifteen display cases in one room on the first floor, and dismissed in the 1816 edition of the *Synopsis* with the words: 'not being strictly of a scientific nature, no further detail is here given of its contents'.[2]

The 1808 edition, however, had described this as 'one of the most conspicuous parts of the Museum', thus signalling at this early stage in its evolution the tension already emerging in the British Museum between the perceived interests of the visitor and the research priorities of the staff.

The minutes of the meetings of the trustees shed light on the daily growing pains of the British Museum. Early on there were parking problems. Knight's successor as Principal Librarian, Charles Morton (1719–99), was asked to remove his sedan chair from beneath the colonnade where no doubt it was getting in the way of visitor circulation (13 August 1779). There was vandalism by readers: Joseph Planta (1744–1827), the Librarian in charge of Manuscripts, reported that pieces had been cut out of Harleian manuscripts. The bits were retrieved and stuck back (27 August 1779). Health and safety concerns arose early when a visitor's carriage was damaged by a stone vase that fell off the colonnade. Somebody might have been killed, so the surveyor 'advised that [the vases] be entirely removed' (7 January 1780). Planta was well ahead of colleagues who looked after the objects, as he and his staff had published a catalogue of the Harleian manuscripts, and by 25 February 1780 had sold 124 copies. We can see museum management issues such as these echoing down the centuries, all re-emerging in the concerns of town and city museums worldwide today.

One event seriously disrupted the museum. During the anti-Catholic Gordon Riots in June 1780 the British Museum gardens and some of its rooms were requisitioned for the use of the regiment of 600 officers and men sent down from York to protect London. They camped neatly in the grounds, as Samuel Hieronymus Grimm shows in his watercolour of the scene. But the sting was that the trustees, not the government, had to pay for accommodation and provisions for this army of temporary occupation. When Colonel Stanhope Harvey's York Regiment

OVERLEAF
The encampment of the York Regiment outside Montagu House, 1780, by Samuel Hieronymus Grimm.

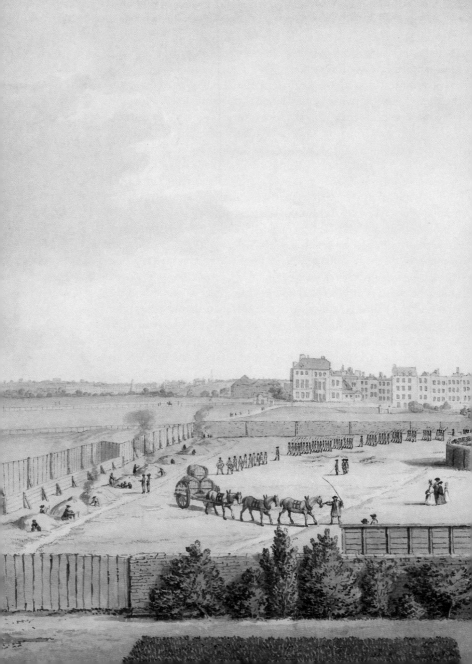

withdrew after two months, and 'expressed their gratitude in repeated cheers' (18 August 1780), the Museum had to pick up the pieces and count the cost.

Now acquisitions were flowing in as if on a high spring tide, their pressure and extent revealing weaknesses in the museum system and its physical structure. Three rooms had to be cleared of printed books and reorganized to accommodate the Museum of the Royal Society prior to the Society's move from Crane Court, Fleet Street, to Somerset House (18 May 1781). The rich and fascinating bequest of Rev. Clayton Mordaunt Cracherode, greeted in 1799 by the trustees as 'a most valuable legacy... books, drawings, prints, coins, medals, gems, minerals and shells collected with the greatest care and skill', was found to be technically liable to tax, so the trustees had to find some way around that (21 May 1799). As if this was not enough, forty years on from its opening as a place of recreation, reflection, interest and enjoyment for thousands of visitors, Montagu House was beginning to fall to bits, and was reported once again to be 'much in need of a general repair' (11 May 1799).

In its first half-century of existence, the British Museum continued its process of attracting collections and shedding them. Deaccessioning could be brutal. Sloane's stricture that his collection should 'remain together and not be separated' had to be tempered by rough reality. Banks supervised the burning and burying of zoological rubbish, much to the disgust of locals who complained of the smell. In the 1830s the painter Richard Reinagle discovered the head, beak and legs of a dodo when he was looking through a heap of animal skins. A magazine of the time remarked: 'Mr Reinagle has not been able to learn what became of the fragments, but they ought still to be somewhere in the British Museum.'[3]

In the years surrounding the arrival of the Cracherode collection, the Museum received Sir William Hamilton's collection of Greek, Roman and Neapolitan objects (1772), David Garrick's

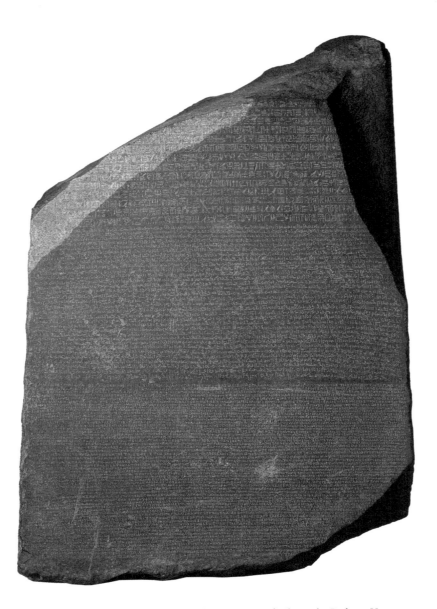

The Rosetta Stone, 196 BC. Carved with three versions of a decree by Ptolemy V in hieroglyphic script, demotic and Ancient Greek, the stone slab was an essential tool in helping scholars to decipher ancient Egyptian hieroglyphics.

library of plays, books and pamphlets (1779), and the mineral collection of Charles Hatchett (1799). The Rosetta Stone arrived in 1802, followed by extensive quantities of Egyptian antiquities taken from the French in Alexandria, the classical sculpture collection of Charles Townley (1805), the Greville Collection of 20,000 mineral specimens (1810), the 'Elgin Marbles', now known at the Museum as the Parthenon Sculptures (1816), the Bowditch African collection (1818), the ethnographical and natural history collections of Sir Joseph Banks (ongoing, until his death in 1820), the library of King George III (1823), and the collection of drawings, gems and bronzes from Sir Richard Payne Knight (1824). This mass of objects was of course in addition to the small varied deposits from visitors and well-wishers that meant much to the donor but received no public applause. Among these were a 13-ounce (370 g) piece of iron 'extracted from the head of Mr Sam. Steel Chief mate of the Grenville West India packet, the same having been in an engagement on the 10th Sept last, shot through the eye and lodged in the head out of sight, of which wound the said Mr Steel is now recovered' (17 December 1779). This object was of extraordinary particularity, not for what it was but for what it had failed to do. Other objects have a baffling inconsequentiality, such as 'an Incrustation formed within a square Pipe from Philip Thicknesse Esq of Bath' (1 June 1792). Invariably and impartially the trustees would record their thanks for 'these presents'.

Complications arose when donors attempted to keep control. Even so powerful a figure as Sir Joseph Banks failed to strike a bargain with his fellow trustees when he proposed a 'system of exchange' such that he 'be permitted to deposit in the British Museum such articles as Trustees may approve of... and... to request in exchange for them such duplicates of the collection... as he may have occasion for'. The trustees, who kept a firm grip on the Museum's management, had a brisk response, declaring clearly that:

All such articles as Sir Joseph Banks shall deposit... shall be considered as part of the collection, and actually the property of the Trustees from the time they are delivered to the officers of the House; and that the Trustees shall have full power at all times to reject every application from Sir Joseph Banks for duplicates in exchange for them, which they may think unreasonable. (9 April 1802)

The British Museum's existence provided a route for collectors to achieve some kind of immortality through an important donation, a source of money (more usually for collectors' families), and a home for such stuff as members of the public might believe fair-mindedly to be of interest to a wider audience. And that audience was widening. The ticketing system for admission was abandoned in 1810, and as a result visitor numbers rose dramatically: just over 15,000 in 1809–10; nearly twice that in the following year, and by 1822–23 it was approaching 100,000 a year. The countless objects arriving, large and small, demanded space for storage and display, and created the physical pressure required to generate political pressure to extend and repair the building.

As early as 1802 the trustees discussed the need for phased expansion. The coming of the Townley collection (bought from the collector's family for £20,000) prompted the construction of a new wing designed by George Saunders. This opened in 1808 to house not only Charles Townley's marbles, but also, in its following wind, parts of the Cracherode, Sloane, Cotton and Hamilton collections. Thus by clever diplomacy, flexibility, opportunism and timely pragmatism, the trustees were able to draw together political, cultural, administrative and personal pressures to create the necessary climate to make a series of monumental acquisitions that were in effect world changing.

Central among these were the purchase at auction in 1814 for £15,000 of the Greek 'Phigaleian marbles', comprising the Temple of Apollo from Bassae with its figured frieze. Two years later,

An illustration by Thomas Prattent of the Townley Gallery at the British Museum, as designed by George Saunders, from the *Gentleman's Magazine*, September 1810.

after much campaigning for and against, the sculptures from the Parthenon were purchased by Parliament from Lord Elgin for £35,000 and deposited in the British Museum in perpetuity. The sculptures continue to be a cause of controversy between Britain and Greece, which, since gaining its independence from the Ottoman Empire in 1832, has made frequent requests for them to be returned. The marble frieze and surviving pediment figures had been removed from the Parthenon in Athens between 1801 and 1812 by agents for Thomas Bruce, 7th earl of Elgin, by the apparent authority of two permits issued by the then Ottoman rulers of Greece. These are now lost. The first of the marbles arrived in London in 1802. As their numbers increased they were on show

intermittently at Elgin's home in Park Lane, immediately becoming the object of contentious debate that they remain to this day. The Museum's donor and supporter Richard Payne Knight, who doubted their authenticity, railed against them, while in *Childe Harold's Pilgrimage* (1812–18) the Romantic philhellene Lord Byron denounced their removal from Greece as an act of vandalism:

> Dull is the eye that will not weep to see
> Thy walls defaced, thy mouldering shrines removed
> By British hands, which it had best behov'd
> To guard those relics ne'er to be restored.
> Curst be the hour when their isle they roved,
> And once again thy hapless bosom gored,
> And snatch'd thy shrinking Gods to northern climes abhorr'd![4]

Notwithstanding such objections, the sculptures' bulk and importance demanded proper accommodation. This opened in 1817, a gallery built to the designs of Robert Smirke (1780–1867), the architect to the Office of Works who had been allocated to the Museum by the government. Such a major step also led to an increase in staff for the Museum:

> Upon opening the Elgin Gallery it had been found necessary to employ a person in the capacity of a Labourer for the purpose of lighting and attending the Fires, cleaning the Marbles, and other menial services; and that a person of the name of John Garrett had been employed for similar services during the removal of the Marbles… who had proved himself decent, well-behaved, and sufficiently intelligent. (8 March 1817)

John Garrett was thus 'occasionally employed' for these purposes. While Garrett got his job, the trustees turned down the request for an increase in the wage of the extra attendant in the Museum Hall who took charge of sticks and umbrellas carried by the increased volume of visitors that the new Greek antiquities

OVERLEAF
The Temporary Elgin Room in 1819, designed by
Robert Smirke; oil painting by Archibald Archer.

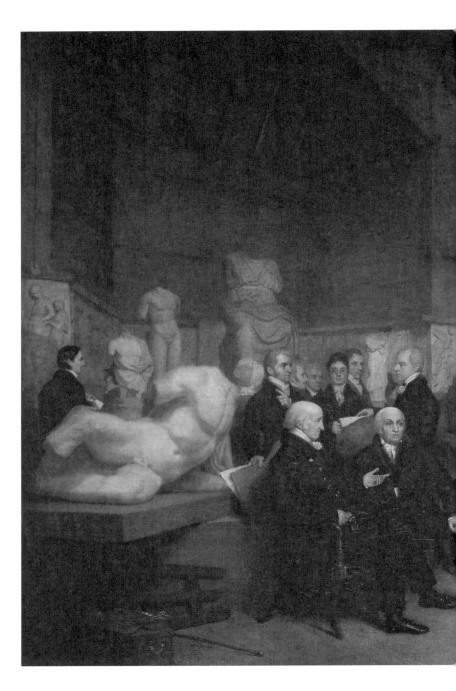

were generating (12 March 1817). The following conversation between visitors was heard by the artist and diarist Benjamin Robert Haydon (1786–1846) in front of the newly displayed Elgin Marbles: 'How broken they are, a'ant they?' 'Yes,' said his friend, 'but how like life.'

Like any modern museum and library the British Museum was at risk from thieves. Soon after its acquisition the Cracherode collection was systematically robbed over a three-year period (1804–6) by Robert Dighton, who, in one part of his extraordinary life, was a popular singer, in another a maker of amusing caricatures, and in a third a thieving art dealer. Befriending the Under Librarian William Beloe, and distracting him with gifts of geese, chickens, fish and peas, Dighton had too-easy access to the Museum's folders of prints and was able to stuff some 'in my pocket... in the bosom of my coat... in a roll in my hand', and take them off to sell. He was not prosecuted when confronted, but let off when evidence against him was thin, on condition that he co-operated in retrieving as many of the stolen prints as possible. The fall-out from this spectacular theft left Beloe dismissed for negligence, the Museum without many of its finest prints, and an imperative from the trustees for the organization to improve security fundamentally.[5] The system of proper registration for the prints and drawings collection was introduced following this incident.

* * *

The British Museum's first publication for general consumption, *Synopsis of the Contents of the British Museum* (1808), is an extraordinary document, being both a guide to the collections at Montagu House, and what looks like a complete transcription of all the acts and votes of Parliament that led to the Museum's foundation and opening. It is not an exciting read. After supplements,

extracts from the *Journal of the House of Commons*, more statutes and rules, duties of officers, lists of the forty-three trustees, and the names of the members of staff from the beginning, 184 pages later we at last get to the gist of the publication and the information that most of its readers wanted – namely, what is to be seen inside the Museum's front door. In publishing such opaque material in the *Synopsis* the Museum's trustees were bolting their institution firmly onto the machinery of state. The British Museum could not be – if it ever was – considered as having an uncertain future. The will of Parliament, assented to by the king, was there in the front of the *Synopsis* for all to read.

Security, such as it was, had been devastated by the Dighton thefts, and the *Synopsis*, published four years after the stable door had been so carelessly left open, shows the new measures taken. 'At no times whatsoever' should the Museum be left without a senior officer present in and around the building and grounds; windows and doors should be shut 'after the companies leave the House'; fires in the stoves must be carefully settled for the night; the messenger and his assistant should keep an eye on 'the hall, passages, (especially those on the basement story) and other places from whence danger may be apprehended' to ensure safety, 'and see that no person is lurking therein'; lighted candles should be carried within lanterns, and 'are never to be brought into the Museum... in any other manner'. Should fire break out the alarm bell was to be rung and 'such of the Trustees as live within a reasonable distance' informed. The Principal Librarian must ensure that the fire engines are kept in good order, and their reservoirs 'be always full, or nearly full, of water'. Indeed fire, not theft, was the principal fear, made the more pressing in the light of the 1731 Cotton Library fire.

What is most interesting about the *Synopsis* is that its authors identified, in what may be one of the earliest manuals of curatorship in existence, the principal responsibilities of running a

museum. Brought up to date, these 'Duties of the Officers' are standard practices that have not changed in succeeding centuries, only been added to or re-ordered in priority.

1 The Principal Librarian should be at the Museum 'as constantly as shall be necessary';

2 He should allow 'persons of eminence... especially Foreigners... extraordinary admission';

3 He must be informed if an object is lost or damaged;

4 The officers 'shall employ themselves in arranging scientifically, and in making catalogues of all additions that may be made from time to time to the collections entrusted to their care; and also in re-arranging the old catalogues, whenever either may stand in need of it', and to make a note of where objects are located;

5 A rota of Under or Assistant Librarians to have one always in waiting at the Museum;

6 Readers should be supplied with the books and manuscripts that they require; and ensure they do not damage the books or manuscripts, or annoy any of the other readers;

7 Officers should conduct themselves as becomes men of honour, integrity, and liberality, in the conscientious discharge of their respective duties, and as men who have the credit and utility of the Institution truly at heart.

Alongside the prestigious acquisitions of the marbles from Bassae and the Parthenon, the day-to-day work of the Museum continued: conserving, registering and adding other, more modest, items to its collection. At a meeting held on 11 May 1816 in which the trustees instructed the sculptor Richard Westmacott to restore the Phigaleian marbles, they also purchased 3,187 specimens of insects for £15 from Mr Sims of Norwich. The following month they acquired Colonel Montague's collection of British

Zoology for £1,100 (15 June 1816). This was plainly a museum for everything – marbles from Greece, insects from Norfolk, and the weighty chunk of iron that had lodged itself behind a sailor's eye in the West Indies.

The British Museum demonstrably collected prints and drawings, but was also at this stage in its history responsible for keeping together the national collection of paintings. By the early 1820s it was patently clear that old master paintings had needs that a building full of bookshelves, display cases and stands of stuffed animals could not supply, and means were being sought to divest the Museum of its responsibility for them. The developing clamour for Britain to have its own national gallery prompted one of its most prominent art collectors, Sir George Beaumont, to bequeath in 1826 his collection to the British Museum and to engage in a guileful political manoeuvre in league with Museum trustees. Beaumont's initial aim was to encourage the government to allocate money for a picture gallery within the Museum. In the end, however, the oil painting collection, with the exception of Founders' portraits, was transferred to the new National Gallery in 1828, and the gallery space that was being constructed to house old masters was instead hung with the Museum's collection of portraits high above cases of minerals.

In 1823 the land behind and to the east side of Montagu House was about to become a busy building site with Robert Smirke now confirmed as official architect to the trustees. The Townley Gallery to the west was still satisfactory, but after only ten years the temporary building housing the Parthenon Marbles had fallen into a 'precarious state' (4 January 1826). Smirke gave the trustees his advice on expansion, which they codified in a set of nine demands to the Treasury. These would make the continuously evolving British Museum fit again for purpose. The trustees were setting new standards here and looking to the future: the British Museum was unique in the world, in scale, ambition, worldview

OVERLEAF

The Elgin Marbles! Or, John Bull buying Stones at the time his numerous Family want Bread!!, 1816, by George Cruikshank.

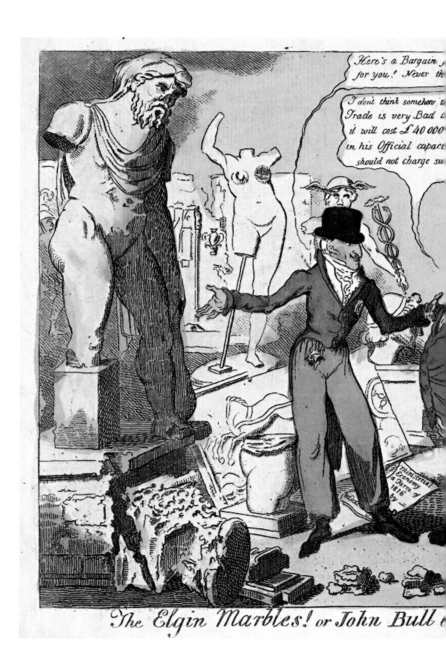

The Elgin Marbles! or John Bull

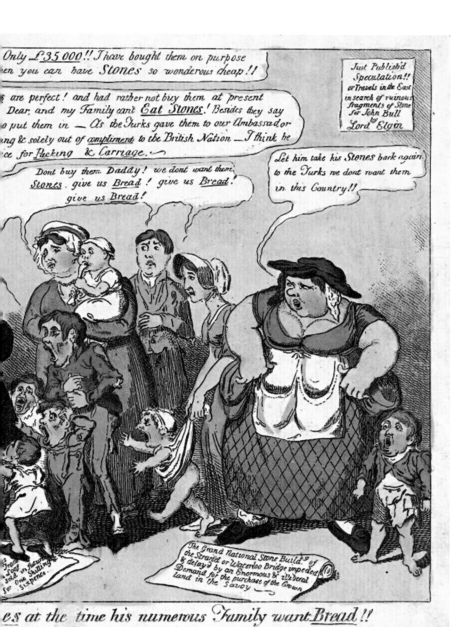

and indeed in its very existence, and pioneered the way for future public museums to manage their growth. The trustees also demanded a flexibility that would enable collections to be resited within the Museum in response to fluctuating pressures of space and popularity.

Demands from a museum to its political masters must be continuous and persistent if it is to make clear to politicians that free museums and galleries are a sign of an advanced civilization that desires to know itself. As early as 1784, resisting a call for admission charges from one of their number, Sir Joseph Banks, the trustees confirmed that 'even if the amount of such [admission] revenue could be in any ways ascertained… it would be but a small proportion of the deficiencies of the regular expenditure of the Museum'. The British Museum thus remained, and indeed continues to be, a free museum. Future directors, among them Sir Frederic Kenyon, Sir David Wilson and Neil MacGregor, would eloquently defend the principle behind free entry two centuries later (see Chapter 7).

In the same way that museums offer knowledge and understanding to the public, so support from above must be offered to them. This is how the British Museum trustees attempted to articulate their needs to the politicians in June 1826:

1 [In the face of the continuous growth of printed books] 180,000 volumes will require at least double the space of the King's Library in the East Wing which amounts only to about 60,000 volumes.

2 [Following the departure of the picture collection] Mineralogy will occupy the upper floor of the East Wing; Zoology and Botany may be placed properly on the upper apartment of the West Wing [Townley Gallery].

3 Easy communication between the upper floors is a priority for staff and visitors.

4 A Print Room of sufficient size must be provided, and properly lit preferably from the north.

5 A Medal Room with adequate security to be constructed.

6 Etruscan Antiquities will require an apartment better adapted to its contents than the present.

7 A Board Room for the Trustees with ante-chamber and retiring closets is required.

8 A small apartment or Sitting Room is required for the Principal Officers of each Department as a Study or Working Room.

9 Workshops for the Museum's bookbinders and engravers are required.

The trustees might also have included requests for more room for umbrellas and walking sticks, and extended working space for the Museum's plaster-casters, who generated revenue for the institution from the incessant demand from other museums, colleges and private collectors for casts of antiquities. From the Greek antiquities, for example, a price list of 1838 reveals that a plaster cast of a figure of one of the Fates from the Phigaleian marbles cost £22, and a horse's head was £1 5s. The trustees' minutes note that a cast of the Rosetta Stone was requested in 1829 by the directors of the Museum and Library of Columbia College, New York (11 April 1829).

The trustees' meeting minutes report continuously on their support for what would now be lumped together as 'curatorial matters'. For example, the Rembrandt drawings in the Payne Knight collection were so much in demand by copyists that in 1825 the Trustees banned all copying from them until they had been engraved. This ban did not extend to drawings by the lesser seventeenth-century Dutchman Adriaen van Ostade, reflecting their awareness of the relative importance of these two artists

(12 February 1825). Further, it was pointed out that stuffed animals – an Arctic dog, a goat from Nepal and a small seal and an otter – on open display in 'the 11th Room upon the Natural History stor[e]y' had been damaged, and that glass cases should be provided for such objects in future (10 July 1824).

It was the practice of the trustees to demand bonds from new staff members on their appointment, to confirm their loyalty. When Henry Ellis (1777–1869), already Keeper of Printed Books and subsequently of Manuscripts, was appointed Principal Librarian in 1827 he was obliged to put down a bond of £2,000 'for the faithful discharge of his duty as Principal Librarian', and a further £2,000 'for his separate Office of Receiver and Expenditor to the Trust'. This was an anti-corruption device, making it imperative that the post-holder behave himself or, before any legal action, lose his money (12 January 1828). Lesser bonds were demanded from new Under-Librarians. This indicates that you had to have access to money to be appointed to a professional post at the British Museum.

The British Museum was now a lively and popular place, busy, engaging and consistently fascinating. Tom and Jery [*sic*], the pair of fictional young-bucks-about-town created by the journalist and comic writer Pierce Egan (1772–1849) in his *Life in London* (1821), were taken round the Museum by a 'Conductor', indicating that the early practice of mandatory guided tours had evolved into an unofficial public service. Gifts came in from all quarters and from all types of people, many from those who might be described as the 'intelligentsia', demonstrating how deeply the British Museum had by now entered the nation's consciousness. Gideon Mantell, the natural philosopher and pioneer of the understanding of dinosaurs, was one donor; others included the poet and collector Samuel Rogers; the artist, writer, traveller and polymath William Brockedon; and the painter Benjamin Robert Haydon who, in June 1830, donated 'several pamphlets by himself on Art'

(12 June 1830). The bequest of the virtuoso collector Richard Payne Knight, its 1,000 drawings, 800 bronzes and many dozen gems, came with the condition that a member of Payne Knight's family be given a place on the Board of Trustees in perpetuity. While this obligation lingered on until 1963, when it was abandoned, the particular presence of Payne Knight's collection in the Museum is noted by the special stamp used to mark his drawings. Responsibility for the stamp's design was delegated to the trustee Sir Thomas Lawrence, president of the Royal Academy, and the distinguished medallist Benedetto Pistrucci: 'the circle of the stamp to be formed by the words BRITISH MUSEUM, and the initials R P K to be inserted in the centre' (10 July 1824).

The Museum enthusiastically engaged natural philosophers – known today as 'scientists' – fully into its activities. The 1808 *Synopsis* evinced clear understanding of the forward march of scientific knowledge:

> It might be expected, that, in consequence of the great progress made of late years in the science of Natural History, the collection of Sir Hans Sloane, which, when it was purchased, was deemed of the first magnitude, would insensibly become retrograde in its comparative value: and this in fact was found to be particularly the case in the classes of Ornithology and Mineralogy. Accordingly... many additions were afterwards made by purchase and Donation, and the aggregate soon formed... as extensive and curious a collection as any perhaps at that time extant.

The generation of Sir Joseph Banks was succeeded by that of the chemist and teacher Sir Humphry Davy (1778–1829), who became a trustee and brought new ideas to the Museum. He proposed to devise and supply a glass case that was 'perfectly airtight, and composed of permanent materials, for the purpose of preserving Specimens of Natural History' (13 November 1824). The science of preserving organic material was beginning to catch

up with the science of studying it, and we have museums to thank for that. Both Davy and his colleague William Wollaston were asked to examine 'for purposes of experiment' cinders and burnt fragments of the Cotton manuscripts caught in the 1731 fire. Davy was well acquainted with fire-damaged manuscripts, having examined parchments discovered in the excavations of Herculaneum, devastated by the eruption of Vesuvius in AD 79.

It was becoming increasingly obvious that the growth in the number of books and the inexorable rise in the quantity of museum objects received would result in collision. This was inescapable, and the status quo recognized to be ultimately unsustainable. Nevertheless as the nineteenth century advanced the British Museum continued on its way: visitors increasing, buildings deteriorating, budgets shrinking or at least not keeping up with requirements. A collection of fifty kangaroos, comprising '23 or 24 species' was turned down in 1840 because the seller wanted £100 for them and there was only £68 left in the zoological collection budget (26 September 1840). On the other hand, Henry Ellis was delighted to report to the trustees a year later of his 'hope that the whole of letter A in the New Catalogue of Printed Books would be printed off by the end of this month' (10 July 1841). That was a major step forward for its compilers; only another twenty-five letters to go.

In the 1840s the British Museum was still more heavily weighted towards natural history and printed books and manuscripts than it was towards archaeology, ethnography, ancient history, coins and medals, and prints and drawings. While these were all increasing rapidly in their quantity and in their demands for storage and display space, those sections of the collection that were to remain at Great Russell Street into the twenty-first century represented, then, only a minor part of the whole.

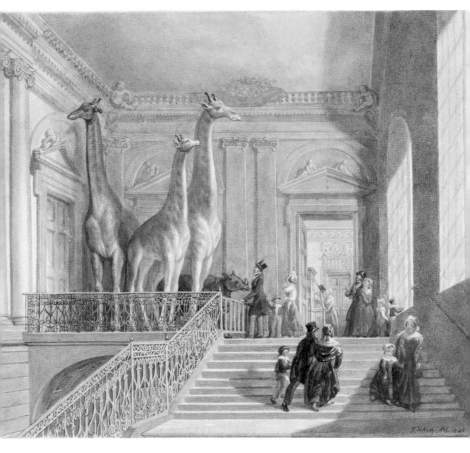

The staircase of the old British Museum, Montagu House, with giraffes, rhinoceros and visitors, 1845, by George Johann Scharf.

Decades of Reconstruction 1821–1846

'The want of accommodation'

Robert Smirke RA, smooth, energetic and genial, was a Tory architect par excellence. Before he was appointed to the British Museum he had built, or was in the process of building, Lowther Castle in Westmorland for the earl of Lonsdale, the new Theatre Royal, Covent Garden, for the actor-manager John Philip Kemble, and bridges, town halls, churches, barracks, hospitals, courts, gentlemen's clubs and country houses all over Britain. He had also been the architect called in, together with his ingenious contractor Samuel Baker III (1761–1836), to rescue failing buildings and projects, including the Customs House and Millbank Penitentiary.

The years after the Battle of Waterloo (1815) saw a resurgence of public building at a time when Smirke was beginning his rise in the architectural profession. This suited him perfectly. The styles he adopted were the Greek Revival and the Palladian manner, products of years as a young man spent travelling and drawing in Italy and Greece, where he witnessed Lord Elgin's men removing parts of the Parthenon frieze. Smirke's technical hallmarks were his extensive and subtle use of cast-iron columns, perforated cast iron for beams, concrete for foundations, central heating, and integral fire precautions such as slate floors and copper roofing. The Prussian architect and ambassador Karl Friedrich Schinkel (1781–1841) had a good look at the building under construction when he visited London in 1826, and reported back to his government.[1] Prussia, like Britain, understood the value of museums as a potent expression of soft power. The British Museum was a testbed for modern materials and building techniques; it was the combination of modern materials and Samuel Baker's ingenuity that made Smirke's buildings work, not the classical forms that clothed them.

When Smirke was appointed the Museum's architect the trustees did not know that they would be embarking on a significant and enduring relationship not merely with an individual, but

Bust of Sir Robert Smirke, 1845, by Thomas Campbell.

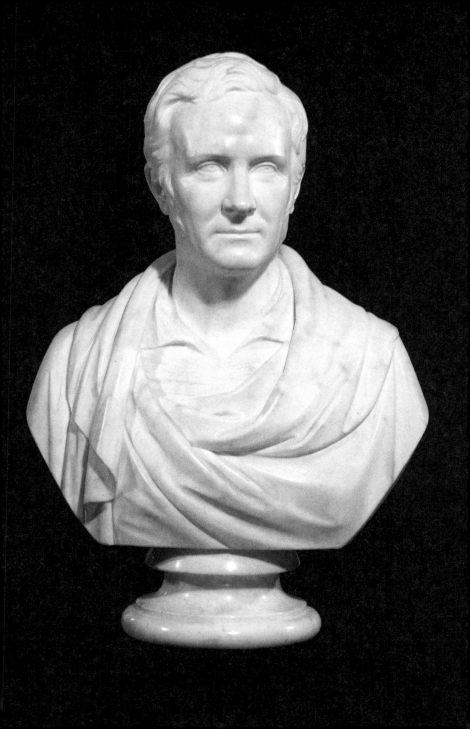

with his family. Rather than stay at Montagu House the trustees were briefly tempted to move the entire collection lock, stock and narwhal tusk to Carlton House at the eastern end of Pall Mall, by then vacated by the Prince of Wales. But sense prevailed, and in 1821 Smirke presented plans for new east and west wings. With £40,000 voted by Parliament in 1823 to build an east wing, the King's Library, with space also for the Sloane, Harley and Cotton manuscripts, Smirke's genius for evoking gravitas and articulating space was able to find its greatest expression. Samuel Baker's technical skills and man-management prowess were also essential, for the site gradually revealed particular difficulties, such as waterlogging, that he would have to overcome. One of the Museum's cadre of attendants, John Conrath, kept a brief diary which has survived. On Monday 8 September 1823 he noted: 'The first bricks were laid for the foundation of the new building at the British Museum near the east end of the old house, the ground being springy I saw the bricks and mortar laid in water. The foundation is about twelve feet deep.'[2]

Baker was the man who made the architect's desire for the wide spaces of the King's Library a reality, and who made his demand for concrete foundations work. He was diligent and alert to the needs of the task ahead. When the artist George Johann Scharf Snr (1788–1860) visited the site during long peregrinations around the city in July 1828, he spoke to Samuel Baker who gave him some idea of the quantities of stone involved in building the British Museum. In the margin of one of his drawings of what was then said to be the largest building site in Europe, Scharf wrote: 'There will be 44 Columns to the Façade, and 10,000 Tons of Stones used as Mr Baker the Builder told me.' There are indeed forty-four columns to the façade, so clearly the bones of Smirke's design were laid early. Such huge quantities were unprecedented in a British public building. Baker was clearly intent on impressing Scharf, and through his agency this extraordinary man expressed

precisely and proudly the trustees' ambition and purpose in their great project.[3]

Scharf's drawings show construction in full swing: the King's Library is completed and out of sight, while the Townley Gallery stands somewhat forlorn in the middle distance, its days numbered. The west wing now rises beside it, and the corner of 'poor condemned' Montagu House, as Charles Lamb put it, awaits its end. Museums devour themselves: what is good new accommodation in one decade may be disposed of as unworkable in the next. It is poignant to note that the Principal Librarian responsible for the building of the Townley Gallery, Joseph Planta, appointed in 1799, was also the man responsible for ordering its demolition. Auction notices held in the Museum archive tell the brutal story of construction, demolition, auction and construction again. But for the future, Scharf shows how timbers and blocks of dressed stone lie about ready for use, and the site teeming with workmen and their tools. The evidence of Scharf's drawing, one of a series of detailed pencil and watercolour studies, demonstrates the momentum that the trustees had already generated in advancing the Museum's development.

The scope of the work being carried out must have made it clear to a reluctant Treasury that it could not be checked, and that the Museum's expansion had a momentum that was unstoppable. As well as being the largest building site in Europe, this was quite probably also the noisiest, and the noise would continue into the 1850s; the Round Reading Room was under construction between 1854 and 1857. Evidence of the inconveniences suffered by Bloomsbury residents survives. Frederic Madden, the Museum's Keeper of Manuscripts, who lived on site, complained of the 'extreme annoyances, privations and discomforts… during which time the masons' work for hewing stones was carried on close beneath his windows… insufferable dirt and noise…' and the 'indecencies of the work people'. Life must also have been extremely

OVERLEAF
The Townley Gallery, with Smirke's new west wing under construction, 1828, by George Johann Scharf.

fig. old gallery of Antiques in the British Muse

Sir Robert Smyrk
is the Architect

There will be 44 Columnes to the Facade, and 10
as Mr Baker the Builder told me

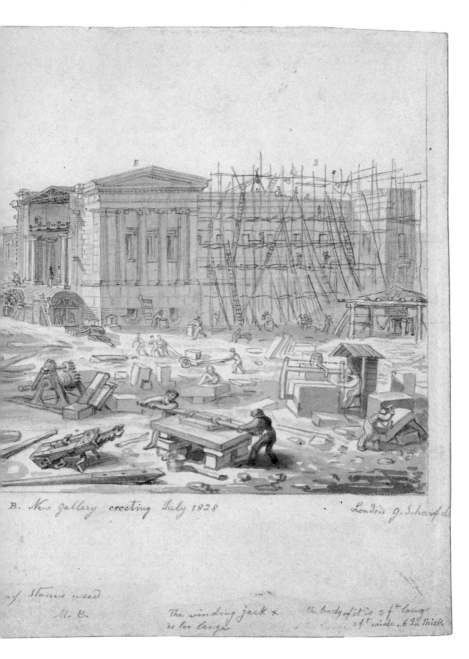

B. New gallery erecting July 1828

London G. Scharf del

of Stones used
Mr B.

The winding jack x
is too large

the body of it is 9ft long
1ft wide. 6 In thick

difficult for those in the reading rooms, where studious silence will have been breached by the sound of builders at work.

* * *

The early curators, Knight, Maty and Morton, were by now long dead. They had died not only in post, but actually on site; death at Montagu House for curators was not unusual. There were no pensions; curators lived on site and carried on until they dropped. When Joseph Planta was promoted to Principal Librarian in 1799 after already twenty-six years' service, the Museum was still a Sloanean conglomeration of books and curiosities; when he died (at the Museum, of course) in 1827, having become the longest-serving employee, he had overseen the acquisition of the Townley, Payne Knight and Cracherode collections, the Phigaleian and Parthenon Marbles, and the Egyptian antiquities including the Rosetta Stone. The Museum's transformation, a triumph of the nineteenth century, had begun in the eighteenth. As the architectural historian J. Mordaunt Crook eloquently put it, 'the institution made the building as the turtle makes its shell'.

The Museum's acquisitions in this period reflected Britain's growing imperial reach based on the dominance of its navy. The Egyptian antiquities began to arrive following the puncturing and deflating of Napoleonic ambitions in the eastern Mediterranean at the Battle of the Nile in 1798. Assyrian antiquities were also starting to enter the collections: it was during Joseph Planta's Principal Librarianship that Mordaunt Crook's later observation 'a museum knows only one law: expansion' became plainly apparent.[4] Planta responded to this inescapable fact by promoting and seeing through not only so much construction, but also the first secessions experienced by the Museum. Sloane's collection of 'monsters', that is, his bottled biological oddities, was sent to the Hunterian Museum in London's Royal College of Surgeons

in the early 1800s, and old master paintings were transferred to the new National Gallery in 1828.[5] Portraits, with the exception of the Founders' portraits, would go in the late 1890s to the National Portrait Gallery.

What Planta conducted in Bloomsbury was an overture to modern times. During this period the trustees' minutes became more coherent and ordered, sub-committees were formed, and the Museum's opening hours extended. The trustees' grip on affairs lightened by degrees. Mandatory guided tours were discontinued, universal free access ensured, and conservation work and the forensic examination of objects for scholarly purposes began. Artists and art students were admitted to draw; public relations with other organizations at home and abroad were fostered, not only by scholarly exchange, but also through the lucrative business of selling plaster casts. Guide books were published for all types of visitor requirement, research continued for catalogues of the collections, staff salaries were increased, and, in 1818, gas light was introduced into the courtyard of Montagu House (14 February 1818).

One example, among many, of Planta's management of the changing way of thinking concerns the care of the collections, as expressed by the then Keeper of Antiquities, Taylor Combe (1774–1826). Writing in his department's *Description of the Collection of Ancient Marbles in the British Museum* (1812), Combe declares:

> We cannot refrain from expressing our strong disapprobation of the too frequent practice of repairing the mutilations of ancient marbles; these *reparations*, even when executed with consummate skill and ingenuity, are often any thing rather than *restorations*. In works of classical literature the scholar will never consent to admit conjectural interpolations into the text of an ancient author, and surely the same correct feeling ought to be extended to the remains of ancient sculpture, so as to preserve them from the injuries of conjectural restoration.

The courtyard of Old Montagu House with views of the
Keepers' residencies, 1840s, by John Wykeham Archer.

Combe was here touching on the practice, common enough
in Rome in the workshop of the sculptor/restorer Bartolomeo
Cavaceppi (1716–99), of treating archaeological remains as if
they were exhumed works of art for sale to collectors rather than
evidence from the past. Thus 'antique' sculpture, with misguided
or mischievous repairs and reconstructions, spread deep into
the collections of British grand tourists. Combe saw it as his
responsibility to ensure that the Museum distanced itself from
such practices.

The ambition and extent of Smirke's grand intentions for the British Museum prompted discussion of London's wider infrastructure. Though Montagu House was ideally placed between Westminster and the City, the existing street patterns did not provide the easiest access to the Museum. The slow, painful birth of Smirke's new building was accompanied by a stream of proposals for street improvement which over the decades were mooted, debated and shelved. In 1825 John Nash proposed a scheme that would link Charing Cross and the British Museum via Seven Dials. This would have created a gentle curve comparable to his executed Regent Street scheme. Of this the young architect Thomas L. Donaldson wrote:

> Among the projects now afloat that of street cutting is the most popular... The nobs in the West End, enraged that so many good things should be so far Eastward, made a great noise in Parliament. The Government anxious to justify their proposition in Parliament desired Mr Nash to form an ample & noble access thereto as the West enders complained that they could not get at the Museum at all.[6]

Five years later, Parliament discussed another idea, that a new road be built to connect Waterloo Bridge with High Holborn.[7] It happens that a straight line from Waterloo Bridge runs directly north-northwest to the centre of the British Museum portico. This could have made an ineffably grand avenue, with St George's, Bloomsbury, Sloane's parish church, prominent on a new traffic island, and an arrow-straight boulevard redolent of civic planning in Paris or Berlin. Land ownership, however, was against it, and in any event it would have been out of character for London.

It is intriguing to consider briefly how differently London might have developed had the trustees chosen Buckingham House

as the home for the British Museum in the 1750s, as indeed they might have done. Instead of Aston Webb's façade of Buckingham Palace, redesigned in 1913 from Edward Blore's 1830 original, we would likely have had a version of Smirke's Bloomsbury scheme. However, the larger Buckingham House site would have spawned a Museum with a rather different shape, able in theory to extend in three directions, into St James's Park, Green Park and what are now the Palace Gardens. The Mall, then a wooded public promenade, may eventually have become the grand approach that Nash and others had foreseen for Bloomsbury in the 1820s and 1830s, and which Aston Webb realized in the 1900s. But where would George III and Queen Charlotte have chosen to live when St James's Palace became effectively uninhabitable? That one decision of the trustees not to take Buckingham House had a silent but profound effect on London's future planning. A royal palace growing elsewhere in the capital would have given London quite another shape.

* * *

Through the industrial, commercial and social revolutions of the first half of the nineteenth century, Smirke's conception for the British Museum evolved to its final form. During its planning and construction, the Museum itself evolved behind its chrysalis of columns from a huge, unwieldy and barely understood cabinet of curiosities, to one in which antiquity began gradually to assert its precedence. The Museum was the agent for the bringing together of things, the raw material of empiricism, to enable the widest intellectual experiment to take place. As rubble from the old Montagu House was carted away and its fittings auctioned off in the 1840s, the ancient Greek roots now growing in the Museum's collection sprouted columns on the façade one by one,

creating an outward expression of the Greek world within. The British Museum has the scale of what in Italy, France, Germany or Russia might have been a royal palace. This, however, is Britain. The British Museum, hemmed in by residential and commercial buildings, became a palace for the people to enjoy as their own in the crowded heart of London, furnished with things they owned, for this was the *nation's* collection.

The possible surprise arrival of bequests, gifts and unexpected collections makes it difficult for any museum to plan for its expansion. It is sometimes the case that museum directors woo potential large-scale gifts and bequests in order to force expansion or shape-change; others may wait until the approach of bursting-point turns expansion into potential explosion. The British Museum's trustees were the pioneers for museums all over the world in the use of political leverage to achieve growth, here driven by the effects of global politics, European conflict and imperial ambition.

It was now plain to all with responsibility for the British Museum that expansion was the only law the Museum knew. The trustees and curators knew it, regular visitors knew it, and this universal rule must by now have become clear even to the Treasury when in 1832 the trustees drafted an important letter urging it to reconsider its opinion on the process of the expansion (see Appendix 5). While building work behind Montagu House was proceeding in accordance with Smirke's design, the trustees' problem was one of maintaining cash flow and influencing political priority. The Treasury was aware of the Museum's ambition, but did not want to apply to Parliament for money to build the north block until after the completion of the west wing. This is how the Museum put its alternative case:

> The Trustees feel the method of proceeding with the new
> building at the Museum to be a matter which so strongly affects

OVERLEAF
The King's Library, 1875, a photograph by Frederick York.

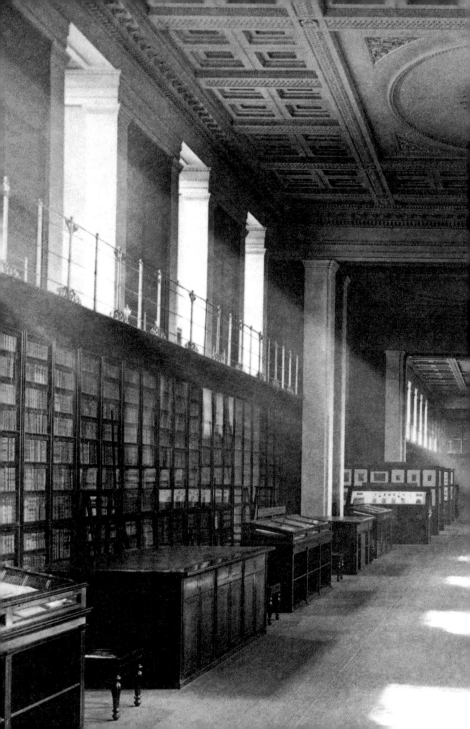

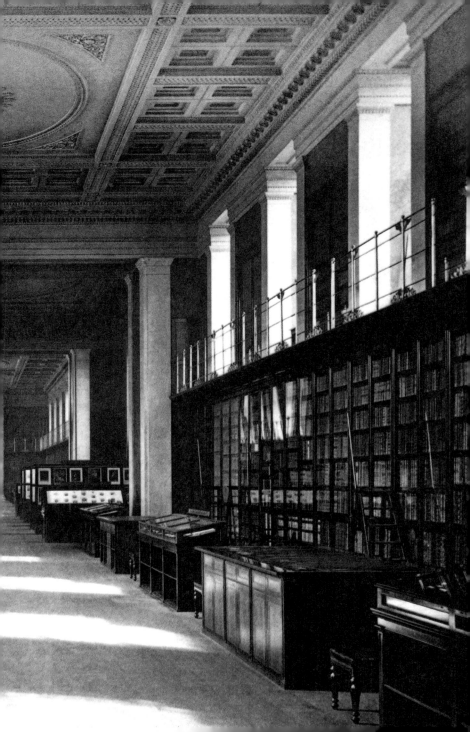

both the interests and convenience of literary men and the safety of the literary treasures committed to the charge of the Trustees, that they think it their duty to press again upon your Lordships' attention some of the more important circumstances which induce the Trustees to desire the commencement of the North side in preference to the final completion of the wings.

Note the emphasis here on the 'literary'. Cunningly, the classically educated trustees had stressed an aspect of the Museum's work with which they knew the classically educated members of the Treasury committee would feel a natural kinship. Using the plight of a suffering butterfly collection or of a stuffed Arctic dog would not have had the same effect in the 1830s as it might in the 2010s. Pressing their case, they insisted that while the existing near-complete pair of wings was sufficient for the time being, the new north wing was necessary now to provide temporary overspill for the collections while the Museum was in flux, and space for inevitable growth. The main problem was the quantity of books and the pressure from readers:

The want of accommodation for the increasing number of Readers may readily be conjectured by Your Lordships from the facts that upwards of Forty Thousand visits are now annually made to the Library of the British Museum for the purpose of research, and that the increase of students is so rapid, that which in a week of March 1830 they amounted to 564, in a week of April 1831 they were 650 and in a week of December no less than 839.

The urgency of the trustees' appeal to the Treasury was a product of the explosion of publishing, the growth of literacy, and an awakening of interest in the wider world as the nineteenth century advanced. While progress in the physical growth of the Museum was accelerated by the needs of printed books and manuscripts, other departments expanded into the new west wing following its completion in 1834. There, on the upper floor,

parts of the natural history collection were housed, alongside the Etruscan vases, Payne Knight's bronzes, and smaller and lighter-weight objects such as mummies and grave-goods from Egypt. The ground floor took the massive weights of the Museum's Egyptian sculpture dominated by the giant head and arm of Amenhotep III, the pair of red granite lions also from Amenhotep's reign, and the Rosetta Stone. Nearby were the Parthenon sculptures, the marbles from Bassae, and further conglomerations of Greek and Roman antiquities. Such generous and wide-ranging displays also, however, created disorder. Thousands of visitors relished their journey through this portal to exotic new worlds, but muddle was clearly an irritant to more ruminative visitors. A contributor to *The Times* wrote in 1838:

> It would be an excellent opportunity to test the effect of the coloured [Grecian] statues if these figures were placed on an appropriate pediment, not like the paltry wooden frame into which they at present appear compressed, and placed over the entrance to the great Egyptian gallery of the Museum, almost immediately over the spot occupied by the lions. There is in this part of the building both height and space sufficient for such an experiment; at present they are crowded together in a miserable obtuse angle of painted deal, the handiwork of the carpenter of the establishment, and the derision of all persons of common taste and judgement![8]

While it was impossible to please everybody, the primitive early displays in the new extensions to the British Museum began to galvanize the Museum's public and open the doors of perception.

The Mid-nineteenth Century

'The expense will no doubt be great, but so is the nation which is to bear it'

Smirke's architectural programme for the British Museum demanded the demolition of Montagu House. The carts that in 1842 carried its rubble away, took away also the crumbled frescoes of Apollo in his chariot, and the other gods of classical myth painted on ceilings of the front hall by Charles de Lafosse. Thus all traces of the idea of the old museum as a cabinet of curiosities disappeared, and the seventeenth-century French artist's fluent imaginings were replaced by Smirke's stout and rational coffered ceilings. The fundamental realignment of the philosophy of the British Museum as expressed through its architecture was complete when, ten years later, the Great Russell Street façade was enclosed by cast-iron railings that people could see through. These replaced the impermeable 12ft (3.6 m) high granite wall that had hidden Montagu House from the street since the seventeenth century. The British Museum was now itself an encased object on free public display.

Even before it was completed in 1846, Smirke's building was too small for its purpose. With the products of distant civilizations, including Egypt, Assyria and Lycia (now part of southern Turkey) entering its collections, the Museum was growing at a rate that had not been anticipated or fully provided for, even by the forethought of Planta and the trustees of the 1830s. Many of these new exhibits were huge and heavy. With their supreme physical, intellectual and emotional energy, archaeologists were casting new light on the history of sculpture – and thereby of civilizations – far back beyond fifth-century BC Greece, into the new-found lands of the second and third millennia BC. The British army was no longer an occupying force in Egypt supplying the Museum by conquest. Instead a small army of diplomats and amateur archaeologists set to work, led in Egypt in the 1810s and 1820s by Henry Salt (1780–1827) and Giovanni Belzoni (1778–1823); in Assyria in the 1840s by Henry Layard (1817–94) and Hormuzd Rassam (1826–1910); and by Charles Newton (1816–94) in Halicarnassus (Bodrum, in

what is now southwest Turkey) in the 1850s. Their finds, made possible by individual feats of strength, survival, courage and diplomatic cunning, illuminated the diversity of the ancient Near East, whose riches were now entering European consciousness in a steady stream.

These were extraordinary men: Salt a diplomat and fixer; Belzoni a former circus strongman from Padua; Layard an artist waylaid by archaeology and politics; Rassam, born in Mosul, an archaeologist and later a diplomat; Newton a salaried curator at the Museum. All were seduced by the demands of distant travel, the thrill of uncovering the remains of extinct civilizations, and the intellectual excitement of searching in these ancient cultures for patterns of meaning and purpose for the developing British Empire. Edward Gibbon's *History of the Decline and Fall of the Roman Empire* (1776–89) chronicled the falling apart of western Roman civilization; Shelley's 'traveller from an antique land' who found 'two vast and trunkless legs of stone'[1] in the desert indicated what might be dug up; and Salt, Belzoni, Layard, Rassam and Newton, among others, went to find it and bring it back. It is easy to forget that museum curators, far from the myths of their inhabiting dusty basements crammed full of stuff, or perching high in ivory towers, are in fact at the front line where civilizations of the past meet our own. The cruel murder by ISIS/Daesh in 2015 of the eighty-three-year-old Khaled Al-Asaad, Head of Antiquities in Palmyra, is evidence of that.

Belzoni's account of removing the colossal head of Amenhotep III from Thebes, by Nile boat to Alexandria in 1817, was entertainingly retold by the journalist Blanchard Jerrold in *How to See the British Museum in Four Visits* (1852), a small book that epitomized the Museum's new understanding of its responsibility for ensuring that the visitor had a good time and learned something interesting. Jerrold's book reflects a popular hunger for vicarious excitement which would, later in the century, be fed by the stories

OVERLEAF
The gateway of Montague House during demolition, 1846, by John Wykeham Archer. Smirke's new building can be seen rising in the background.

THE BRITISH MUSEUM

of Rider Haggard and Conan Doyle. Haggard's Allan Quatermain and Doyle's Professor Challenger both craved the excitement of archaeology, a thrill that was sparked by the real-life courage and energies of Salt, Belzoni, Layard, Rassam and Newton:

> It was no easy undertaking to put a piece of granite of such bulk and weight on board a boat that, if it received the weight on one side, would immediately upset; and, what is more, this was done without the smallest help of any mechanical contrivance, even a single tackle, and only with four poles and ropes, as the water was about eighteen feet below the bank where the head was to descend.[2]

<p style="text-align:center">* * *</p>

Following accusations of nepotism and elitism at the British Museum made in 1833 by the traveller, polemicist and politician William Cobbett MP (1763–1835), the government set up a select committee to investigate. The spark was Cobbett's opposition to the proposal that £16,000 be voted for the upkeep of the Museum. Goaded by another MP's remark that anybody 'with a decent dress' could gain admission, he observed:

> Those who had not decent dresses were required to pay for the maintenance of the Museum. The chop-stick in the country, as well as the poor man who mended the pavement in town, had to pay for the support of this place; and, if they derived no benefit from it, they ought not to be compelled to pay for it.

He went on to attack the inequity of the Museum's opening hours:

> The hours during which it was open were just such as were most inconvenient to the labourer and the tradesman… from ten in the morning till four in the afternoon; just the time when persons engaged in business were the most actively employed. It should be open, in summer, at all events, from six in the morning till ten at night… It was shut up during two months in the year also, exclusive of the other holidays. And what were

those months? Why, September and October. The long vacation; when all the lawyers and parsons, and lords and loungers, were out in the country enjoying shooting. It was then that the Museum was shut up; and yet they were told that it was intended that the people should have the benefit of the institution.[3]

The then assistant Keeper of Printed Books, Antony Panizzi (1797–1879), spoke robustly in defence of the Museum and its practices, and showed that effectively he shared Cobbett's views:

> I want a poor student to have the same means of indulging his learned curiosity, of following his rational pursuits, of consulting the same authorities, of fathoming the most intricate inquiry as the richest man in the kingdom, as far as books go, and I contend that Government is bound to give him the most liberal and unlimited assistance in this respect.

Panizzi also thought in the same way as the former trustee, the late Sir Humphry Davy, himself once a poor student from the west of Cornwall, far from Britain's cultural centre. Not long before his death, Davy had described how museums were civilization's bastion against barbarism. In *Consolations in Travel*, published posthumously in 1830, he wrote:

> I saw bodies of these men traversing the sea, founding colonies, building cities, and wherever they established themselves, carrying with them their peculiar arts. Towns and temples arose containing schools, and libraries filled with the rolls of papyrus... I looked again, and saw an entire change in the brilliant aspect of this Roman world; the people of conquerors and heroes were no longer visible; the cities were filled with an idle and luxurious population... I saw these savages everywhere attacking this mighty empire, plundering cities, destroying the monuments of arts and literature, and, like wild beasts devouring a noble animal, tearing into pieces and destroying the Roman power.[4]

Panizzi's mission was to create an establishment that would not only protect and illuminate civilization, but also project its values. The Rev. Josiah Forshall, formerly Keeper of Manuscripts, by now elevated to the position of Secretary to the Museum, took the argument further, and advocated a Board of Trustees balanced in their interests and specialities. He told the committee: 'So far as my experience goes, the best Trustees of the British Museum are those who have an earnest desire to promote literature, art and science conjointly, without a devoted partiality to one of the three.'

The select committee's report was published in 1836. Its recommendations would help the British Museum march further along the road of professionalism and modernization, with the longer opening hours that Cobbett advocated:

1 Revise the establishment to be better adapted to the present state and future prospects of the Museum;

2 Reduce the number of Trustees; look for Trustees of eminence in literature, science and art;

3 Create more departments, each with its own Keeper;

4 Separate the post of Secretary from a Keepership;

5 Create clearer pay scales; Keepers no longer to be allowed to hold other jobs elsewhere;

6 Longer opening hours;

7 Clearer and better editions of the *Synopsis* to be written by Keepers combining their expertise;

8 Complete catalogues of the collections to be produced with little regard to making money from them;

9 All objects to be registered;

10 A studio for the making of casts of objects to be established;

11 All of this to be funded by Parliament.

In short, the report urged the Museum to develop curatorship as a profession; pay curators better; clarify the divisions between subjects to show more clearly how they were linked; increase public access; collect and share knowledge; and encourage curators to talk to one another. Finally the hope was that the Museum would receive adequate public funding to pay for this public good.

An immediate result of the report was the creation of a separate Department of Prints and Drawings, under a new young Keeper Henry Josi (1802–45), who would extract relevant items from the Reading Room and transfer them to his new Print Room initially in the Townley Gallery. Another was the arrival in the Department of Antiquities of Samuel Birch (1813–85) who went on to specialize in the oriental collections. The appointment of Edward Hawkins (1780–1867) as Keeper of Antiquities in 1826 fostered a growth in the understanding of the importance of British antiquities, and in 1851 led to the appointment as his assistant of Augustus Wollaston Franks, who would have a profound effect on the Museum. However, far from encouraging curators to talk to one another, the outcome of the 1836 report was that departments tended to become fiefdoms. The farthest-reaching organizational change was the introduction of the Museum's unique calendrical method of registering objects which began to formalize the Museum's practice of accessioning. Thus, an object marked '1837,4-24.3' indicated the year of acquisition (1837); the month of reporting to trustees (4 indicating April); the day of the month (24 indicating the 24th); and the number of the object within a group (3).*

The mid-nineteenth century saw a critical advance in the Museum's engagement with its present and future public. Speaking to the Oxford Art Society in 1849, Charles Newton stressed the profound importance of looking, and of engaging with the

* There were variations to this system from department to department, but it remained generally in use until 2007, when a co-ordinated online system, Collections Online, was introduced for all departments.

Anthony Panizzi in an undated photograph. A refugee immigrant from civil war in Italy, Panizzi transformed the fortunes of the British Museum and guided its future.

objects in the Museum. Taking as his example the 'Elgin Marbles', Newton said:

> Make the sculptures of Pheidias your personal friends, live with them, commune with them, become acquainted with every fold in the drapery, every change in the curves of the muscles, know the colossal outlines of the torsos as the mountaineer knows the outline of the hills, learn to distinguish each horse in the tumultuo us throng of the friezes as a shepherd knows his flock.

The Museum now fully understood and practised its responsibility to enhance human understanding: it did so by ordering, cataloguing, displaying and studying its collections; by conserving them with the aid of science; and by facilitating and widening public access. In short, it offered its visitors an experience that was both educative and entertaining. The collection guides published across the mid-century both by the Museum and by commercial publishers are models of good practice, full of the scholarly detail that would be edited out of a popular publication today. An example at random is the *Egyptian Antiquities* volume in the two-volume series of octavo size* on the antiquities in the British Museum, published in 1832 by the Society for the Diffusion of Useful Knowledge. Dozens of scholars contributed to this series, some from the Museum's staff, others from external universities and colleges, under the editorship of the classicist George Long (1800–79). The text of the Egyptian volume is dense and full, stretching to 400 pages interspersed with wood-engraved illustrations and maps. An opening statement proclaims the series' ambition:

> The object has been to collect from the best authorities, both ancient and modern, such information as will tend to give an interest to what the Museum contains, and to furnish more exact information to the general reader than he will find in

* i.e. a little smaller than a standard modern paperback.

most popular books on Egypt… [and] to supply classical students with additional motives for a laborious and voluntary study of those ancient books, which are in general unfortunately only a compulsory and heartless task.

As these volumes demonstrate, the British Museum was already, by the 1830s, a fellow-traveller, not to say a leader, in Everyman's journey from curiosity to knowledge.

* * *

At the back of Smirke's entrance hall of the Museum was a modest door, aligned with the main front doors. This was rarely used, certainly not by the public. Open it, and beyond was a huge internal courtyard flanked right and left by the east and west ranges of the Museum, the King's Library to the right, and Smirke's replacement of the Townley Gallery (demolished in 1841) and his temporary Elgin Gallery to the left. The gardeners tried to get grass to grow there, even tried some cheerful planting, but the high buildings around the square, the deep shadows in summer, the dense gloom in winter, militated against any such expressions of joy. Instead, it became an echo of a prison exercise yard, traversed hurriedly by staff, one surrounded by porticoes and pediments rather than by iron-barred cell windows. This bleak rectangular space would, however, provide the key to the future for the British Museum under the revolutionary, turbulent and transformative directorship of Anthony Panizzi.

Born Antonio Genesio Maria in Brescello, northern Italy, Panizzi was a former street-fighter and companion-in-arms in Italy with Garibaldi. After numerous political scrapes and setbacks in his native country he arrived in London in 1823 as a battle-scarred refugee. In Italy he had become *persona non grata*, having that year been sentenced to death in his absence

on account of revolutionary activities. By 1828, through natural talent and astute friendships, Panizzi had become the first Professor of Italian at the new University College in London, and, in 1831, he was appointed to the British Museum as an Assistant Librarian of Printed Books. In 1837 he became the Keeper of the department, where his revolutionary and street-fighting instincts found frequent expression. In 1856 he was promoted to Principal Librarian of the Museum.

Boundless energy and a secure grasp of facts and of the dynamics of internal politics, gave Panizzi access to the 1836 select committee, and by 1838 the power to move the Reading Room to larger accommodation in the east corner of the new north wing. In 1842, the passing of the Copyright Act obliged publishers to send one copy of every new book to the British Museum. Panizzi, an empire builder, was able to realize the potential that would accrue to the Museum both from this and from mass influxes of books from other sources. These included the bequest of Thomas Grenville's 20,000-volume library in 1847, and the books that were acquired following Panizzi's success in advocating parliamentary grants sufficient to fill perceived gaps in the Museum's library. 'The expense will no doubt be great,' Panizzi admitted to the Treasury, 'but so is the nation which is to bear it'. Though he had become a naturalized Briton in 1832, such cajoling combined with flattery from an official of foreign extraction was potent and irresistible, and Panizzi got the money.

Things began to move even faster when Robert Smirke's younger brother Sydney (1798–1877) took over from him in 1846 as architect to the British Museum. Just when they must have thought the building work and the noise and the action was over it all started up again, not to one side but in the rectangular heart of the building. There was to be a new Reading Room in the central courtyard. Built across three years, from 1854 until its opening in 1857, around a prefabricated iron frame bolted together on site,

the Round Reading Room gave renewed purpose to the empty space at the heart of the Museum, and marked the dominance within the organization of the Department of Printed Books.

Of the Reading Room's steel and brick construction, carried on apparently behind closed doors, *The Times* wrote: 'In the public view... the magnificent structure when visited will appear to have been created by the wand of a magician. Except to a few favoured visitors it is unknown and has been unseen.' This of course was ridiculous: the building material and workmen entered from the southwest corner of the site, by a special access road off Great Russell Street. *The Times* lapped up the superlative statistics, and reported that while in July 1759 only five readers had used the then Reading Room, in 1856 there were 5,000 a month, with 10,434 new volumes being added to the library that year. One curious observation in *The Times* revealed that the gaps of 27 and 50 feet (8–15 m) between the Round Reading Room and the surrounding quadrangle were made 'as a guard against possible destruction by fire from the outer parts of the Museum'. So if the Museum itself went up in flames at least the Reading Room, and its 25 miles (40 km) of shelving, might yet survive.

The Reading Room's fine and detailed fittings for readers included piped hot water below each desk to keep feet warm in winter, and space for 300 readers each to have a table top of 4 feet 3 inches (1.3 m) in width with inkstand and penholders. No wonder Karl Marx, Arthur Rimbaud, Arthur Conan Doyle, George Orwell and Virginia Woolf loved it so: it was the *beau idéal* of world libraries, one with which every other country would have to compete. Karl Marx was granted his first reader's card in 1850, and, visiting the Reading Room almost daily for thirty years, renewed it annually. Mikhail Gorbachev, when visiting London in 1984 as president of the USSR, observed that some of the complaints about communism could be directed to the British Museum. The writer W. M. Thackeray (1811–63) mused on the power

of the Reading Room, 'that catholic dome in Bloomsbury under which our million volumes are housed'. He gives heartfelt thanks for its existence: 'I own to have said my grace at the table, and to have thanked Heaven for this my English birthright, freely to partake of these bountiful books, and to speak the truth I find there.'[5]

Books and their readers are self-evidently hungry for space, and the siting of the Reading Room in the Museum's bleak courtyard set an early precedent for infill, as one generation with its own building needs followed its predecessor. In the case of the British Museum the generations were only about a decade apart.

The west side of the Round Reading Room under construction in 1855. Photograph by William Lake Price.

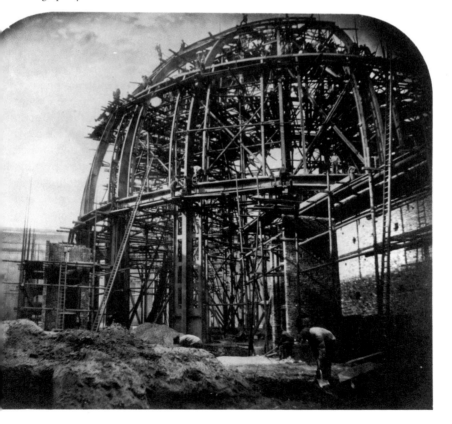

Such pressure to satisfy the needs of printed books exacerbated tense personal relationships within the Museum. This was nothing new. Gowin Knight, the first Principal Librarian, had built a wall in front of his on-site house in the late 1750s to keep his staff out of sight, and passions rose high between the keepers of his generation. Now, in the 1830s and 1840s the Keeper of Manuscripts, Frederic Madden, held the successive Principal Librarians Henry Ellis and Anthony Panizzi in loathing, while he and the Keeper of Antiquities Edward Hawkins and the Keeper of Geology John Edward Gray formed, as David Wilson (Director 1977–91) expressed it, 'the ingredients of a witches' brew of warring satraps, the like of which had never been seen before in the Museum – and has perhaps never been seen since'.[6]

The looming presence of the Reading Room was such that it began gradually to skew the Museum's purpose. Panizzi's grand plan, to have all the world's material culture, animal, mineral, vegetable and printed, under one roof, was bound to have consequences that even 'the great god Pan', as he was known, would be unable to keep in check. The Round Reading Room was Panizzi's attempt to keep the British Museum on one site. The exponential growth of printed books, and the apparent exhaustion of any further significant expansion of the building, meant that crisis would loom in the 1860s. With Henry Christy's 10,000-item ethnography and prehistory collection demanding accession,* and important collections of Indian sculpture arriving, this turtle, to repeat Mordaunt Crook's metaphor, would sooner or later have to split its shell again. The next departure was natural history, a move proposed in the 1860s, confirmed in 1873 when

* Henry Christy (1810–65) was a businessman who travelled extensively in Europe, the Americas and north Africa, and accumulated a collection of some 20,000 prehistoric and ethnographic objects that was offered to the British Museum after his death in 1865.

the construction of Alfred Waterhouse's Natural History Museum in South Kensington began, and finally effected between 1881 and 1883. This in itself began the creation of a new planetary system of museums in 'Albertopolis',† the land acquired out of the vast profits of the 1851 Great Exhibition. A further offspring of the British Museum, the Geology Museum, would grow there in due course, beside the Science Museum and the South Kensington Museum, later known as the Victoria and Albert (V&A). But those are other stories.

It is ironic that the first cause of uncontainable expansion, printed books and manuscripts, was the last Museum department to break away, and even then it broke first only in name, being reconstituted as the British Library in 1973 while still under the Bloomsbury portico. It did not move out until its new building, designed by Colin St John Wilson, opened next to St Pancras Station in 1998. With it went the Department of Western Manuscripts, Stamps, the Map and Music Libraries, and the India Office Library. The Library's break was made inevitable as much as 200 years earlier by the same international forces that drove the nineteenth century itself – the growth of printing, reading, learning, entertainment and the discovery of the world, products themselves of the explosive pressures of the Industrial Revolution and the Enlightenment. 'Only connect', wrote E. M. Forster in *Howards End* (1910); good advice, but some connections had to snap.

† So called to reflect the fact that it was on the advice of Prince Albert that land was purchased in South Kensington for the establishment of new educational and cultural institutions.

From the Victorian Age into the Twentieth Century

'A more delightful occupation
I cannot conceive'

When the Round Reading Room opened in May 1857 it might have appeared that the expansion of the British Museum was complete. May 1857 marked a high point in the culture of Britain's Victorian age. In those same weeks the Manchester Art Treasures exhibition, an event that transformed the way the public encountered art, opened at Old Trafford. The Great Exhibition had opened in London's Hyde Park exactly six years earlier, and in that year, 1851, the British Museum recorded 2,527,216 visitors. Praise for the Round Reading Room was as unstinting as the public response was massive. There was a week of free public access before the building was restricted to readers, and in that week alone, according to figures published by *The Times* in May 1857, the number of curious visitors who came just to have a look inside the new building amounted to 162,489.

In the Museum, however, the home of the things rather than the books, Frederic Madden allowed personal animosity to get in the way of rational thought. He responded to Panizzi's triumph by saying that the Reading Room was 'perfectly unsuited to its purpose, and an example of reckless extravagance occasioned through the undue influence of a foreigner'. Exhibits continued to flow into the Museum itself: sculpture and friezes from the Mausoleum of Halicarnassus, excavated by Charles Newton in 1852, had to be housed temporarily in wooden sheds under the colonnade. As the *Standard* put it in 1860:

> Already if the Overcrowded Lodging House Act could apply to inanimate objects would the Trustees of the British Museum come under the notice of the police, as it continues to be besieged by fresh tenants, to whom it can only offer the door step or a shakedown beneath a temporary shed.

Crowds of people came to enjoy the crowded objects, to the extent that the dust they raised itself caused damage. The scientist Michael Faraday (1791–1867) was consulted by the trustees on this

The Round Reading Room at the British Museum.

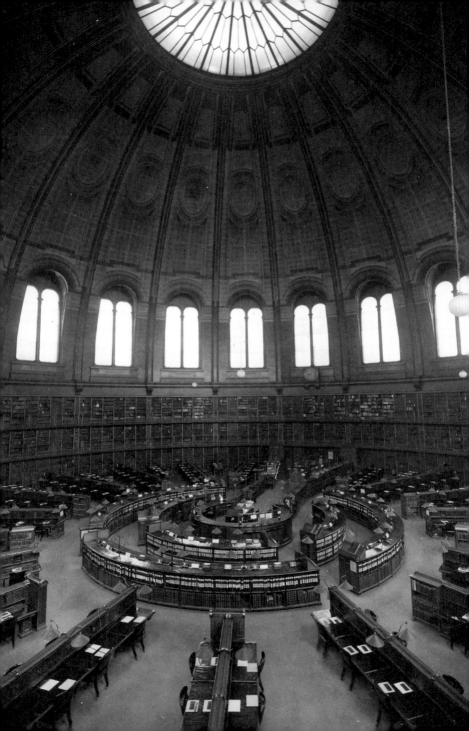

state of affairs in 1857, and was asked to advise on the conservation of the Parthenon Sculptures. They had attracted surface dust, and in cleaning tests Faraday tried dilute nitric acid, alkalis 'both carbonated and caustic', water and rubbing with sponge, finger, cork or brush. He was pessimistic:

> I wish I could write anything satisfactory... The marbles generally were very dirty... The surface of the marble is in general rough, as if corroded;... many have a dead surface; many are honeycombed, in a fine degree, more or less; or have shivered broken surfaces, calculated to hold dirt mechanically... The examination made me despair the possibility of presenting the marbles in the British Museum in that state of purity and whiteness which they originally possessed, or in which... like marbles can be seen in Greece and Italy at the present day.[1]

This may have made uncomfortable reading for the Museum, but Faraday gave them the truth as he had discovered it: that the sculptures were becoming damaged by dust raised by 'the multitude of people who frequent the galleries', and by London's polluted air. There was little the Museum could do about London's polluted air, but as a result of Faraday's advice, and much subsequent discussion by trustees, some surface cleaning using fuller's earth* took place.[2]

A further rush of objects entered the Museum in the 1850s. One curator in particular was central – indeed, instrumental – to the Museum's new collecting pattern. Augustus Wollaston Franks (1826–97), described by David Wilson as 'in many respects the second founder of the Museum', was blessed with an acute sense of connoisseurship, profound knowledge of British archaeology, and extensive private means. He combined these assets to increase the Department of British and Medieval Antiquities collections to

* An absorbent and benign cleaning substance, traditionally used to clean marble, consisting of hydrous aluminium silicates.

the extent that across his tenure as Assistant rising to Keeper, as he put it, '154 feet of wall cases and 3 or 4 table cases... [grew to] 2250 feet in length of wall cases, 90 table cases, and 31 upright cases'. When the Museum could not afford to buy an expensive object such as the Royal Gold Cup made for the fourteenth-century Valois kings of France, he lent the institution £5,000. Franks was the driving force behind the growth of the Museum's British and European archaeology collections. He acquired material openly for the Museum, as well as by proxy, creating his own private collection which in due course he bequeathed to the Museum. This comprised around 7,000 objects of medieval antiquity, including the celebrated seventh-century carved whalebone box which became known as the 'Franks Casket'.

For the Museum he was relentless: year after year he made spectacular additions, both by direct purchase and by gifts and bequests that he elicited from collectors. It was Franks who was behind the acquisition of the Christy Collection in 1865. To take three successive years at random, in 1855, at the thirty-two-day Christie's sale of the collection of the politician Ralph Bernal, he acquired the ninth-century Lothair Crystal, and from the same collection he transformed the Museum's holding of Italian majolica and glass; in 1856 he acquired the Charles Roach Smith collection of 5,000 pieces of British archaeological material; and in 1857 he bought for £40 the 'Battersea shield', a second- or first-century BC decorated bronze and enamel shield that had been found in the River Thames. With such acquisitions, persistent, determined and cunning, acquisitions that were neither dynastic Egyptian, classical Greek nor imperial Roman, Franks altered the British Museum's landscape by refocusing its collecting pattern on the Renaissance and the north. But that was not all: he had the energy, skill and luck also to open up the collecting of artefacts from China and Japan, the Americas, India and the Islamic world, and through all these initiatives to articulate the vision

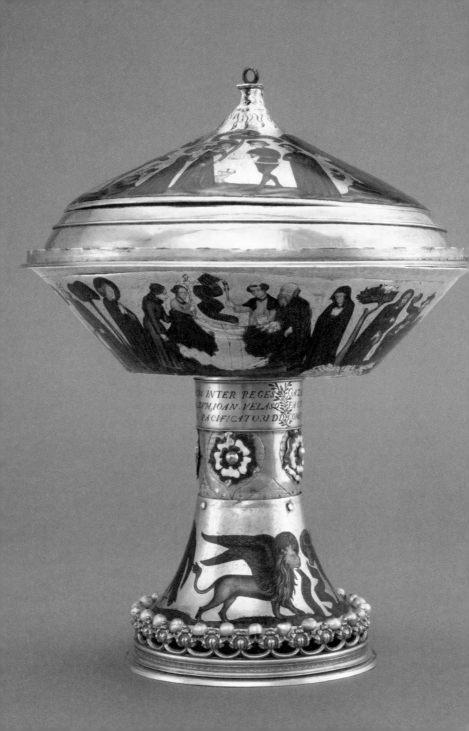

that informs the British Museum's outlook today. By building on the foundations set by Sloane and his successor donors for 'satisfying the desire of the curious', and Planta's seminal classical and Egyptian acquisitions, Franks created through his life's work the conditions that enabled Bloomsbury to become the home of the world museum.

This rush of objects also included 1,000 pieces of ancient glass bequeathed by Felix Slade in 1868. Hoa Hakananai'a, an Easter Island statue taken by the crew of HMS *Topaze*, followed in 1869 as a gift to the Museum by Queen Victoria. Excavated material arrived from Ephesus, Cyrenaica and Rhodes, and in 1872 over two thousand objects from the Castellani collection of gold and bronze antiquities were purchased. Close study of the Museum's existing artefacts produced some extraordinary discoveries. In 1872, the curator George Smith (1840–76), who translated the cuneiform inscriptions on Assyrian clay tablets that he and Rassam had discovered in the Library of Ashurbanipal in Nineveh, found that one fragment revealed an account of a great flood comparable to Noah's flood as described in Genesis. From Smith's discoveries in cuneiform, the earliest known extended written narrative, the third millennium BC *Epic of Gilgamesh*, gradually emerged.

* * *

Visitors to the Museum in their thousands were encouraged both by popular literature and the press, and in answer to commercial pressure the first Museum restaurant opened in 1865 in a basement. However, there were public complaints of the restaurant's growing inadequacy: the portions of potatoes served fell from two to one, and teetotal customers were dismayed by drinkers demanding spirits.[3] It closed after five years, being replaced in 1887 by a new, larger establishment beyond the Egyptian Gallery.

The Royal Gold Cup, c.1370–60. Made of solid gold, the cup is decorated in enamel with scenes from the life of St Agnes.

Electric light arrived in 1879 and 1890, driven by French and German companies, the Société Générale d'Eléctricité and Siemens and Halske, which experimented with the lighting of the Reading Room, the western range of galleries and the Entrance Hall. By 1890 the entire Museum was electrically lit by British Swan lamps, switched on for the first time in a celebratory party attended by 3,000 people.

Something, of course, had to give after the Reading Room consumed the central courtyard. First, space was gradually, but inexorably, released when the natural history collections began to move out to South Kensington in 1880. As *Punch* put it in 1861 when the idea of the move was first mooted:

> Mother Nature, beat retreat
> Out, M'm, from Great Russell Street.
> Here, in future, folks shall scan
> Nothing but the works of Man.

The division that *Punch* identified was neat and obvious. The separation of naturally occurring specimens from human artefacts is the first essential step that any general museum has to take in the sorting of objects, which is the primary requirement of taxonomy. It is remarkable that given so much pressure on space this took so long to achieve at the British Museum; but curators generally like things to be kept together. In 1895, following an earlier act of Parliament, the Museum acquired five and a half acres adjoining the northern side of the Museum, along with the sixty-nine houses thereon. There was now room for its twentieth-century expansion to begin. As *The Times* reported in August 1895, it was 'high time to enlarge the space available at Bloomsbury... the five and a half acres purchased will not be too much for the ever-growing, apparently limitless demands for the housing of treasures fit to be placed in the British Museum.' Public transport in London began to anticipate raised expectations:

PREVIOUS PAGES
An Old Babylonian clay tablet, 1740 BC. Translated, Nanni complains to Ea-nasir that the wrong grade of copper ore has been delivered after a sea voyage and about further delays to its delivery.

the Central London Railway opened a new underground station in High Holborn in 1900 and named it 'British Museum'.*

Generous donors, principally William White and Vincent Stuckey Lean, had left large sums of money to pay for extensions to the Museum, but the money was never enough. While the White Wing was constructed to the east of the King's Library in the 1880s and initially housed the Mausoleum of Halicarnassus, the original plan for the northern scheme, proposed by the architect J. J. Burnet (1859–1938), became overambitious. It would have given the Museum as grand an avenue running north as the southern avenue proposed in the 1820s might have been. While what was constructed does have considerable Edwardian grandeur across its long columned range, Burnet's scheme was severely curtailed. Nevertheless, the Edward VII Building, opened in 1914, did provide the North Library, and a very necessary voluminous staircase, one tall enough to accommodate the 40 ft-long (12 m) totem pole from Queen Charlotte Island, floor to ceiling, and to link new galleries and study rooms for the Department of Prints and Drawings, and for the Map Room, and displays of European and Asiatic ceramics.

The new galleries would also house the Waddesdon Bequest. This magnificent collection of over 250 objects of 'plate, enamels, bijouterie carvings in boxwood, arms and armour', the contents of the Smoking Room at Waddesdon Manor in Buckinghamshire, was bequeathed to the Museum in 1898 by Baron Ferdinand de Rothschild. A condition applied by the donor was that it should be displayed apart from other collections in the Museum, an injunction that has always been graciously observed. A collection such as this was encouraged and anticipated by the Museum. Some incoming collections, however, might be little known to the Museum's curators and emerge out of the blue. One such was that

* It closed in 1933, when it was absorbed into Holborn Station.

OVERLEAF

The new electric lighting at the British Museum,
Illustrated London News, 8 February 1890.

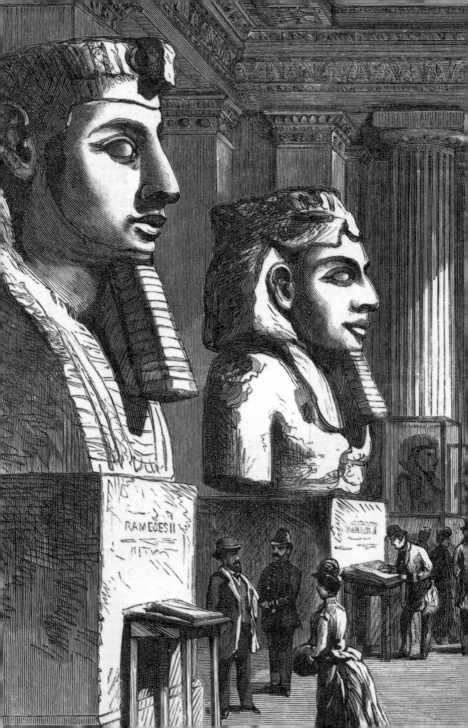

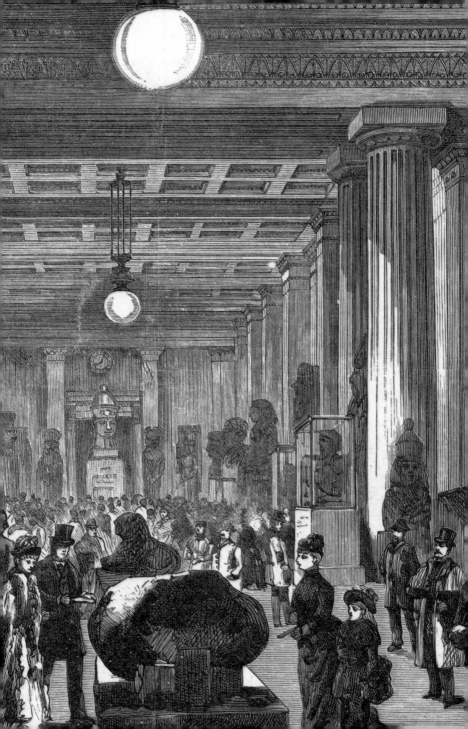

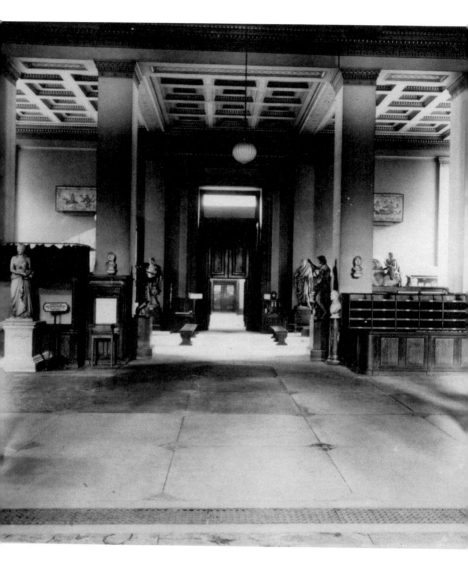

A photograph of the museum's entrance hall in 1929, possibly taken by the Museum's photographer Donald Lyon.

of the Suffolk doctor W. Allen Sturge, who with his wife had collected flint implements; 86,000 of these, weighing 25 tons, arrived in 1918 on Sturge's death. It is the possibility of the unheralded offer of a collection of this kind that lights up the curator's morning with a moment of hope and anticipation. Such moments, however few and far between, will affect the pulse of any museum's purpose, and come to dictate and direct the shifting pattern of its organization. Thus when *The Times* spoke of 'the housing of treasures fit to be placed in the British Museum' it is describing only a fraction of the story, and admitting a small part of a museum's responsibilities. The British Museum is not only about 'treasures', but about the smallest flint implement, the meanest coin, the least consequential print, and what, collectively, these can say about humanity. It is the gap between the treasure and the commonplace object that every curator must manage and express.

Of all the modern professions, curators are among the most competitive in terms of fights for space, money, and recognition of their chosen field within their museum. It is usually assumed that curators love the work they do; such a happy imagined condition this was (and is) that in the 1890s it prompted this outburst from the then prime minister, W. E. Gladstone, to the Keeper of Prints and Drawings, Sidney Colvin: 'I for one would never be party to increasing the salaries of you gentlemen at the British Museum, for a more delightful occupation I cannot conceive.'[4]

The Twentieth Century

*'Knowledge gained should
be spread and shared'*

The First World War, 1914–18, brought a hiatus to the work of the Museum. Retired specialists were recalled to replace members of staff who were withdrawn for military duty, and within the British and Medieval Department collectors volunteered to continue curatorial work. Even the Director, Sir Frederic Kenyon (1863–1952), absented himself to go to France, though he was soon commanded to return to his post at the Museum. Particularly valuable and portable objects were removed for safety at the beginning of the war, and at a greater rate when London was threatened by air raids in 1915. Prints and drawings, manuscripts and other literary treasures went for safety to the National Library of Wales in Aberystwyth, small objects to a station on the new postal railway line beneath Holborn, and large and heavy objects, including the Parthenon Marbles, were carried down to the basement. The Museum's building itself was proposed as the wartime home of the new Air Ministry in 1916, until the principal trustee, the archbishop of Canterbury, and Frederic Kenyon together put a stop to it by intervening with the prime minister, David Lloyd George, and making it quite clear that this highly irresponsible idea would immediately make the Museum into a legitimate target.

If any good came out of the years of war, and the damage sustained by some objects in damp and otherwise unsuitable

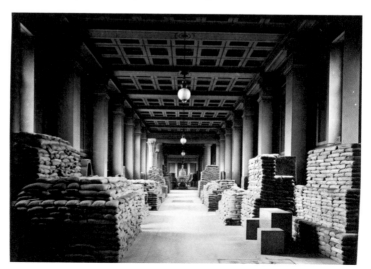

storage, it was the creation early in 1920 of the Museum's scientific research laboratory under Dr Alexander Scott. This was responsible for developing conservation techniques and advising on procedures and priorities, and from this initiative the roots of today's Department of Conservation and Scientific Research in the Museum gradually formed. The ending of war also created opportunities for rethinking the role of national museums and galleries in Britain, and to consider in particular that of the British Museum in the post-war world. The Royal Commission on National Museums and Galleries of 1927 found that while a reconstitution of the government of the British Museum 'would [not] affect any useful purpose', the Museum should begin to take a leading role in promoting British archaeology, and, within its doors, improve signage, labelling and lighting, and consider evening openings. The Commission also proposed that the Natural History Museum in South Kensington become an autonomous body, to be administered separately from the British Museum, and that a dedicated new library for the Museum's ever-expanding collection of newspapers and magazines should be constructed at Colindale, north London.

Major acquisitions continued from the 1920s to the 1940s. The *Codex Sinaiticus*, the earliest New Testament in Greek, was bought from the Soviet government in 1933 for £100,000 after a public appeal, and finds from Leonard Woolley's excavations at Ur in Mesopotamia, from whence such treasures as the copper bull and the gold and copper so-called 'The Ram in the Thicket', entered the collections.* This was a rich period in Eastern archaeology, but following the encouragement of the 1927 Royal

* The copper bull was found crushed under masonry in the remains of the c.2600 BC temple to Ninhursag, goddess of the pastures. The 'Ram in a Thicket' is one of a pair of supporting goat figures discovered in the Royal Cemetery at Ur; the other is at the University of Pennsylvania.

A photograph of the interior of the British Museum during the First World War, 1918.

The Sutton Hoo Purse-Lid, early seventh century.

Commission the Museum began to draw more finds from digs in Britain. The Sutton Hoo burial goods were discovered just before the Second World War, and the Mildenhall treasure was acquired by the Museum just after it. These were not without their bizarre aspects: the Sutton Hoo site, near Woodbridge in Suffolk, was allegedly pinpointed by the intervention of a spiritualist, while the Mildenhall objects of fourth-century AD Roman silver were uncovered by a plough in 1942 and used for some years by the farmer as household utensils until their true value was revealed in 1946 and they entered the Museum. The first-century AD Roman cameo glass Portland Vase, on loan since the eighteenth century, was purchased in 1945. This had been owned by the same ducal family which had so richly endowed the Museum's beginnings with the Harleian collection.

* * *

For the duration of the Second World War the greater parts of the collections were removed to safety in a quarry near Bradford-on-Avon in Wiltshire, to Boughton House in Northamptonshire, Drayton Manor in Staffordshire, and to the deep recesses of the Aldwych tube station. The building, which was severely damaged in bombing raids in 1940 and 1941, was left as an echoing shell, peopled by security guards, sandbags, and some of the largest and heaviest immovable orphaned objects which had to remain. The Roman Britain Room was destroyed, as was the Coin Room. The as-yet-unoccupied Duveen Gallery, which had been completed on the eve of war for the Parthenon Sculptures, had its roof blown in.

After the war, social flux across the nation was echoed in the British Museum in the ordering, re-ordering and reshaping of the curatorial departments, a new understanding of the importance of education and design in the Museum, and the appointment of women to curatorial roles – though very few in fact until the

The Portland Vase, c.AD 1–25.
The famous dark blue amphora, decorated with white cameo glass, was smashed by a drunken visitor in 1845 and subsequently repaired.

1960s. Despite Gladstone's earlier strictures, the pay grades of staff were improved. The original three departments of 1759 had been long submerged into the Museum's nineteenth-century form, and by the early twentieth they were practically unrecognizable. Natural History having departed, the curatorial departments in 1945 were eight: Printed Books; Manuscripts; Egyptian and Assyrian Antiquities; Greek and Roman Antiquities; British and Medieval Antiquities; Oriental Antiquities and Ethnography; Coins and Medals; and Prints and Drawings. Changes continued until the present departmental structure (into ten parts; surely not the last) appeared.[1] As well as providing appropriate homes for the many and various collections within the Museum, these departments acted as beacons for collectors and scholars worldwide.

Under the directorships of Sir Thomas Kendrick (1895–1979; director 1950–9) and Sir Frank Francis (1901–88; director 1959–68) the 1950s and 1960s were years of physical reconstruction of the buildings, a rolling programme of re-creation and improvement of displays, and a general resurgence of public interest and enhancement of scholarly access. The wide spaces of the Duveen

Gallery were repaired and reopened with their new display of the Parthenon Sculptures in 1962, in a clean, sheer, even clinical environment which allowed the sculptures to be closely approached by visitors. The Mummy Room, now brightly lit and crowded with mummy cases, mummy wrappings and miscellaneous grave objects, brought visitors, particularly the fascinated young, nose to nose with ancient Egyptian death practices amid a cacophony of hieroglyphics. Nevertheless, the progress of the Museum's modernization was frustratingly slow. David Wilson, a new young Assistant Keeper in the Department of British and Medieval Antiquities, recalled his first day in post in 1955:

> The Museum at that time was a dark and unremittingly gloomy place. The portico was black with the soot of a hundred years. Those galleries that were open were dimly lighted, but many were still in their bombed-out state or closed and used for storage... There was no public restaurant, no information desk; only a few publications and black-and-white postcards were sold at a counter in the Front Hall... Behind the scenes, dirt and dust were augmented by the smell of the feral cats that lived – and died – in the under-floor conduits of the semi-defunct central heating system.[2]

Frank Francis, who became director in 1959, had been the Museum's Keeper of Printed Books, and thus in ultimate charge of the Round Reading Room. During his directorship the final attempt at keeping the library on site reached its climax, with the publication in the early 1960s of the scheme to demolish buildings on the other side of Great Russell Street. This would have created a large piazza flanked by two wings for a new library, in an evolution of the Round Reading Room in which the Museum and the library would remain geographically proximate. St George's, Sloane's church, would have been an eye-catcher at the southern end of the site, and London would have gained a new gathering place to rival Trafalgar Square. Mrs Lena Jeger, MP for Holborn

The roof of the British Museum showing damage from bombing during the Blitz.

and St Pancras South, long an opponent of the scheme, led the revolt against it, citing in Parliament as early as 1956 that it would lead to the destruction of thousands of homes and businesses.[3] This 'Battle of Bloomsbury' continued for a decade in and out of Parliament, in the meeting rooms of the London Borough of Camden, and in countless private houses. Advocates for the Museum, such as Lord Annan in the House of Lords, saw disaster ahead if the new library were not constructed as proposed, and a 'sorry stage-by-stage dismemberment' of the Museum.[4] Nevertheless, in the event the conservationists prevailed, the streets were saved, and the Museum was forced to think again.

Kendrick and Francis were perhaps the last of the old-style museum directors, those who could puff their pipes and sit in their offices in front of blazing coal fires. Kendrick, a light-hearted, witty and warm scholar, was a good friend of artists and writers such as John Piper, John Craxton and John Betjeman. He disarmingly revealed his enjoyment of the post to a serious candidate applying for the directorship on Francis's retirement in 1968. His tone is heavily ironic:

> The post is a precious prize. Practically no responsibilities. Just occasionally signing a letter or two that someone, who can write better letters than you can, has written for you. Honey-sweet relations with the dear, friendly Trustees, and turtle-cooing with the Staff Side at the Whitley Councils. Above all, abundant opportunity to get on with your own work and no need to hide it under the blotting-paper when you have callers. Any library-book brought to you within minutes. You can even have the Rosetta Stone wheeled in. And, of course, at the end a reasonable expectancy of a life-peerage and the Garter. It's worth it.[5]

Kendrick's humour and irony masks the realities of life for a director of the British Museum: endless committees, financial shortfalls, political demands, potential staff unrest, and the frustrations (as well as the manifold delights) of a continual pro-

gramme of acquisitions, display refurbishments and exhibition management. Over some months in the early 2000s, when they were making mock of the Museum, sections of the press dug up Kendrick's obituary, misunderstood the tone of the letter quoted therein, and took it literally.[*]

The reforming directorship of Sir John Wolfenden (1906–85; director 1969–73) was characterized by a new assertiveness of tone. The establishment of many new curatorial posts was put in train, ethnography moved out to the Museum of Mankind in Burlington Gardens, and the Museum's first 'blockbuster' exhibition took place. *The Treasures of Tutankhamun* (1972), sponsored by *The Times* and *The Sunday Times*, attracted over 1.6 million visitors, an incredible figure still unmatched in British Museum exhibition history. *The Treasures of Tutankhamun* was as much a geopolitical venture as a cultural one, and as a consequence it travelled on across the 1970s to museums in the Soviet Union, the United States, Canada and Germany.

A second innovative director, Sir John Pope-Hennessy (1913–94; director 1974–6), who had reluctantly transferred from the directorship of the V&A, was immediately faced with the prospect of instituting entrance charges, so contrary to the British Museum's nature and founding principles. These had been driven through Parliament as an austerity measure during the last months of the Conservative government of Prime Minister Edward Heath. On his first day in his new post, 2 January 1974, Pope-Hennessy found that the ticket machines, installed before Christmas beneath Smirke's portico, had been affected by damp and failed to work. The 10p per person charge – the intention was that it would rise

[*] The Museum came under attack in the press in 2000 when it was revealed that 'the wrong kind of stone', i.e. Caen rather than Portland limestone, had been used in the construction of the internal south portico of the Great Court. Caen stone is brighter than its Portland equivalent, and some officials were dazzled by it. It is unlikely that anybody is really bothered about this now. 'Caught out by the wrong kind of stone', *Daily Telegraph*, 25 August 2000.

to 20p in July and August to catch the tourists – was perforce temporarily waived at the British Museum, and withdrawn three months later when Harold Wilson's Labour government returned to power. The government minister responsible for seeing through the controversial policy of entrance charges at national museums and galleries was the then minister for the arts, Lord Eccles, who was, incidentally, also chairman of the trustees of the British Museum. He had evidently not been paying sufficient attention to the history of the museum for which he was responsible. The issue of museum charges had waxed and waned in party politics, as the earlier director, Sir Frederic Kenyon, had written:

> The question at issue is a very simple one. Is it desired to encourage the use of the Museum or not? There is not the slightest doubt that the imposition of fees discourages attendances... The nation has a very large capital invested in the Museum, and it is better to look for the return on it from the educational advantages offered to the public, than from a trivial taking of cash at the Turnstiles.[6]

Kenyon's argument, evidently ignored by Lord Eccles, was essentially the same as that employed by the Trustees against political pressure to introduce entrance charges in 1784 (see p. 70). It remains as valid today as it was in the 1780s and 1970s.

David Wilson, by now no longer an Assistant Keeper in the Museum, but Professor of Medieval Archaeology at University College, London, succeeded Pope-Hennessy as director in 1977. *The Spectator* wrote of him thus:

> Pugnacious, irritable, impatient and charming, the director of the British Museum moves about his office with the stride of Struwwelpeter's Scissorman, and as wicked a grin to match. Amidst the backsliding within the museum profession... Sir David stands out as the champion of the scholar curator, for he is both.[7]

HM Queen Elizabeth II visiting *The Treasures of Tutankhamun* exhibition in 1972.

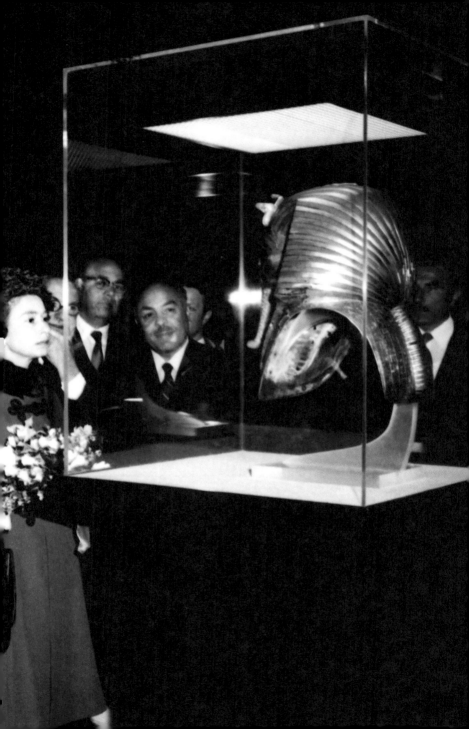

Wilson took a historian's approach to his directorship when he foresaw the need to draw the ethnography collections back from the Museum of Mankind to Bloomsbury. There was an economic imperative also: the rents on Burlington Gardens were colossal. Exercising the centrist principles that underpin the British Museum's foundation, this move demonstrated the importance of collections reacting to one another on one site. Despite the fact that it ran contrary to the internal pressures of space that compel collections to regroup and move out, the move was achieved in 1997 when the Museum of Mankind closed.

By now the departure of the British Library was inevitable: its foundation stone at St Pancras was laid by the Prince of Wales in 1982. The removal of the books and manuscripts a decade later had a profound effect on the British Museum and altered forever its centre of gravity. Before – every day, week, month, year – readers trooped in and out intent on close study in the Reading Room, a distinct and directed silent purpose. From June 1998 they were gone, the Museum's visitors now having perhaps a looser, more fugitive purpose, no less real, but certainly different in kind. The laying of the British Library's foundation stone marked the beginning of the recalibration of the British Museum, and challenged it to think afresh about its future.

David Wilson wrote a key text as director: the polemical *The British Museum: Purpose and Politics* (1989), and, after he retired, *The British Museum – A History* (2002). Together these mark the twin poles of his directorship, a practice of the art of politics in setting out clearly what the British Museum was about, and the centrality of the scholar in drawing a picture of where the Museum had come from and where it was going. Under the directorships of Robert Anderson (1992–2002) and Neil MacGregor (2002–15) the Museum continued its journey into the hearts, minds and cognizance of all. During Robert Anderson's term, the redevelopment of the central quadrangle, designed

by Norman Foster as the Queen Elizabeth II Great Court, was conceived and constructed. There and elsewhere in the Museum public educational and enlightening events could be delivered with increasing pace and imagination. The Museum became more visibly a medium for public education.

These were years of physical transformation comparable only to the Smirke years. Neil MacGregor's directorship, from 2002 to 2015, saw exhibitions grow in range, focus and popular appeal: *The First Emperor: China's Terracotta Army* (2007) was followed by further exhibitions that united scholarship with showmanship: *Shakespeare – Staging the World* (2012), *Ice Age Art* (2013), *Germany – Memories of a Nation* (2014), *Defining Beauty – The Body in Ancient Greek Art* (2015) and *Sunken Cities* (2016).[8] As a natural corollary, loans to and partnerships with other museums increased. The Enlightenment Gallery, conceived during Robert Anderson's directorship, opened in 2003 to mark the 250th anniversary of the first British Museum Act, and in 2015 the Waddesdon Bequest was redisplayed for a twenty-first-century audience in what used to be the Department of Western Manuscripts Study Room.[9] The Museum's reach broadened through MacGregor's first radio series, *A History of the World in 100 Objects* (2010), and expanded further in radio series linked to exhibitions, *Shakespeare's Restless World* (2012), *Germany: Memories of a Nation* (2014), and *Living with Gods* (2017). Together, these plainly and pugnaciously demonstrated the Museum's far-reaching philosophical underpinning, and the evolution of its curatorial diplomacy through cultural exchange in objects, knowledge and advice. Speaking to the *Guardian* newspaper in 2005, MacGregor reminded readers that the British Museum's founding principle was an expression of the ideas of the seventeenth-century philosopher John Locke: that all knowledge should have a civic outcome, and that knowledge gained should be spread and shared.

Into the
Twenty-first Century

*'What a paradise the
British Museum is'*

There is a natural tension within the philosophy of the British Museum's collecting pattern. While its responsibility for butterflies and narwhal tusks is long gone, as has any significant role in the collecting of printed books and manuscripts for the nation, it remains the nation's repository of antiquities from around the world. It is a crucial component of the international network for maintaining archaeological record and security, and one of the many global institutions that share the task of preserving the evidence of human history through artefacts. This responsibility to look into the past is balanced by the Museum's practice of collecting contemporary material worldwide. This arrives daily, from coins and badges to such objects as a wood-and-paper model typewriter, telephone, radio cassette player and motorbike all made in Penang in the 1980s, and a Ghanaian coffin in the form of a Mercedes car.[1] These latter acquisitions, reflecting local rituals surrounding death, have human resonance that reaches back to the Ice Age. The acquisition of contemporary prints and drawings descends also from the Museum's early decades when it accepted gifts of prints and drawings, some by artists still living, from such collectors as Richard Payne Knight and Clayton Cracherode. There was little controversy then. However, in the twentieth century an 'inherited prejudice' took hold against using public money to buy contemporary art. While this could be and was circumvented by gifts, it was not until 1967 that a modest acquisition grant for the purpose was agreed.[2] Other national institutions across Britain have developed their individual missions to collect the graphic art of our time, principally the Tate and the V&A, and, as regional museums and art galleries expanded in the last four or five decades of the twentieth century, museums from Orkney to St Ives have collected contemporary art on behalf of their region at least.

It seems reasonable to ask whether the British Museum needs to continue to collect the art of today when so many other

Paper effigies from Penang, Malaysia. These symbols of worldly success are burnt as offerings to recently deceased relatives.

organizations are pursuing that path? The answer to this must always be yes, because the Museum's perspective is unique, exploring the evolution of graphic technique as much as tracing the flexible priorities of human expression, and is worldwide rather than national. Its principal aim, to demonstrate human practice rather than make aesthetic judgements, might give us cause to reflect that those forty-four columns that clothe the Museum's entrance act as filters for perception: they are the baleen in the mouth of a whale that traps rich krill for nourishment. They signal a fresh approach that demands fresh thinking from every individual: what is art in the Tate and the V&A is the product of humankind in the British Museum. Only (in Britain) in the British Museum could there be a comprehensive display revealing the evolution of, say, etching internationally from Rembrandt (a seventeenth-century Netherlander) to Jim Dine (a contemporary American pop artist), or the lithograph from Senefelder to Géricault to Nevinson, or ink drawing from Botticelli to Claude to Whistler to Nguyen Thu.* We call these people 'artists'; they were, but they were also remarkably dextrous *human beings*, and it is for that reason that their work is in the British Museum. While antiquities emerge by their nature out of the past, the British Museum holds within itself a responsibility to carry public appreciation and understanding of the progress of graphics, through acquisition, cataloguing, publication and display, in a manner that must look both forward in time as well as back.

An internal dilemma presented itself when in 1975 Frances Carey was appointed Assistant Keeper of Prints and Drawings with the particular responsibility of building up the Museum's

* Alois Senefelder (1771–1834), German inventor of lithography; Théodore Géricault (1791–1824), French artist; Christopher Nevinson (1889–1946), British artist; Sandro Botticelli (1445–1510), Italian artist; Claude Lorrain (1604/5–82), French artist working in Italy; James McNeill Whistler (1834–1903), American artist working in England; Nguyen Thu (b.1930), Vietnamese artist.

collection of twentieth-century drawings, bringing it 'up to date'. Among the drawings she recommended for purchase was *Drawing no. 1 1975* by the sculptor William Tucker,[3] a group of ruled geometric cyphers drawn with a felt-tip pen on torn newspaper, with the text columns upside down.† This caused concern among the trustees when they viewed the new acquisitions at their meeting in September 1975; one trustee, the distinguished art historian Lord Clark, is alleged to have said on seeing the Tucker drawing, 'This is the end!' With such a remark, made in the light of the furore that was then raging at the Tate Gallery over its acquisition of Carl Andre's *Equivalent VIII* (1966), the so-called 'Tate bricks', Clark was making an instinctive aesthetic judgement rather than one born from the perspective of an institution devoted to preserving the fruits of human creativity. The minutes record that the meeting heard from John Gere, the then Keeper of Prints and Drawings, that 'so far Miss Carey had been given her head and Mr Gere did not think that it was desirable at this early stage to attempt to direct her interests'. At the following meeting some level of discord and unhappiness emerged at the uncompromising and reductive nature of the Tucker drawing. The trustees as a whole were, like Clark, making an aesthetic judgement:

> The Director [Pope-Hennessy] reported that he, in common with many Trustees, had been disturbed at the quality of the drawing by William Tucker which was shown to the Board at its last Meeting. As a result he had asked the Department of Prints and Drawings to compile two lists, one of modern artists of high standing whose reputations had remained stable over the last 50–75 years, and the other of the material by these artists in the collections. The Director intended that a policy for collecting works of modern art should be based on these two lists. (25 October 1975)

† An arrow on the mount, indicating the way up, was added after acquisition.

Silent Stars

What is a Jew?

Funny underwear

This reflects something of the Museum's discomfort when navigating between the demands of telling the story of, for example, ancient Egypt, which is, essentially, complete, and the demands of demonstrating the evolution of printmaking and drawing that will never reach an end. In plotting the forward route of graphics, the Museum finds itself perforce in the business of prediction as opposed to identification. The business of identification is an essential part of the Museum's remit, being trusted as the repository of the real thing, the 'gold standard' against which comparable artefacts can be measured. Even fakes can be genuine museum objects, 'real things' in their way, as the small display of fake £1 coins demonstrated as a warning and an exemplar across the months in 2017 in which the new 'unfakeable' £1 coin was issued by the Royal Mint.

Echoing the policy of the Department of Prints and Drawings to confront tradition and innovation in contemporary graphics, the Museum's Department of Coins and Medals organized in 2009 the exhibition 'Medals of Dishonour', which traced the history of medals commemorating and satirizing events and actions perceived as dishonourable from the sixteenth to the twentieth centuries. The exhibition also included contemporary medals commissioned by the British Art Medal Trust marking and commemorating relevant people and events including Tony Blair and the Iraq War. Made by artists, among whom were Jake and Dinos Chapman, Grayson Perry and Richard Hamilton, the medals, proofs of which were presented to the Museum, show the Museum tracing the satirical and political role of the work of medallists of the past into today's world. This innovation is of precisely the same kind as the impulse that drives the Museum's practice of acquiring contemporary drawings and prints. In every case there is a story to be told. Prints and Drawings, and Coins and Medals, collect both backwards and forwards; Ancient Egypt collects back. The British Museum plays the part of Janus:

Drawing no. 1, 1975, by William Tucker.

museums do not stand still, and at all times must take a 360-degree view.

* * *

From the beginning it was understood, if not axiomatic, that artists and art students were among the most important constituencies of British Museum visitors. They are specifically mentioned in early editions of the *Synopsis*, and so important were they to the purpose of the Museum that special days and extended hours were instituted for their convenience.

However, a mishap that took place in January 1832, when a student carelessly moving his easel knocked two fingers off the Townley Venus, caused a hurried reassessment of the Museum's priorities. Individual artists had been in the habit of burying themselves in the Museum and its collections; Benjamin Robert Haydon, among many others, made closely observed drawings of the Parthenon Marbles soon after they were installed. J. M. W. Turner was a happy visitor to the Print Room in the 1820s when he was seen looking carefully at a print, and drawn in the act by the then Keeper of Prints and Drawings, J. T. Smith. The profound knowledge of contemporary graphics held by successive Keepers Sidney Colvin (1845–1927) and Campbell Dodgson (1867–1948) led them to find subtle ways of overcoming prejudice against the Museum acquiring works by living artists. What may not be bought with public money could be accepted as gifts from well-wishers, who would include artists and these Keepers themselves. Colvin and Dodgson also used the Contemporary Art Society as a back channel to draw gifts into the collections.

Artists are among the clearest means by which the civic centrality of the Museum's purpose is broadcast: it has indeed been a crucial meeting place for artists, students and collectors, and ease of public access was a priority. The twentieth-century French

collector César Mange de Hauke left his rich collection of nine-teenth-century French drawings, including works by Renoir, Seurat and Van Gogh, to the British Museum because, when he was a schoolboy in England, he was admitted to the Print Room and could see what he wanted. He would not, he believed, have been so freely admitted in the Louvre.[4] In the twentieth century we can cite Jacob Epstein, Henry Moore, David Smith, Eduardo Paolozzi and Grayson Perry as artists whose creative use of the collections has varied in kind and approach as times have changed.

The sculptor Henry Moore made the most of London as a student at the Royal College of Art. He wrote home in 1920:

> Yesterday I spent my second afternoon in the British Museum with the Egyptian and Assyrian sculptures – An hour before closing time I tore myself away from these to do a little exploring and found… in the Ethnographical Gallery – the ecstatically fine negro sculptures… How wonderful to be in London (says country-bred Harry).[5]

Out of this and other visits emerged Moore's *Woman with Up-raised Arms* (1924–5; Henry Moore Foundation) inspired by the great arm of Amenhotep III in the Museum's Egyptian Galleries. Reflecting in 1925 during a scholarship in Italy, Moore wrote: 'If this scholarship does nothing else for me, it will have made me realize what treasures we have in England – what a paradise the British Museum is.'[6]

That same year, as he reflected later, he 'came back to ancient Mexican art at the British Museum'. With the Elgin and Phigaleian Marbles around the corner, and classical Greece and Rome bound indelibly into the Museum's architectural fabric, nevertheless it was the power of the Egyptian, Assyrian, African and Mexican sculpture that affected Moore at this early and formative stage. Passing through the filter of the forty-four columns, Moore

discovered alternative ideas within. Moore's ruminative letters to friends demonstrate how the breadth of the range of the collections in the British Museum fired up and redirected this thoughtful and determined young artist. Sixty years and a career later, he would write this in his Introduction to *Henry Moore at the British Museum* (1981): 'In my most formative years, nine-tenths of my understanding and learning about sculpture came from the British Museum.'

Moore's experience has a particular resonance when we look back to the 1800s and compare the responses then of curators and visitors to the Museum, and the changes over nearly 200 years. In the 1808 edition of the *Synopsis* the exhibits in Room I on the first floor of Montagu House, comprising *inter alia* objects from Asia, Africa, the Americas and the South Pacific Islands, are all listed as 'Modern Works of Art'. The display is introduced thus:

> In making the selection that is here exhibited from a large store of similar materials deposited in a less conspicuous part of the house, a preference has been given to such articles as may best serve to illustrate some local custom, art, manufacture, or point of history; but many even of these will gradually be set aside, to make room for others of more intrinsic value.

There is a mild tone of dismissal here, declining to accept that these parts of the collections were of any great importance. Nevertheless, in a proper museum way, exercised at the very beginnings of what may be termed the 'museum movement', the objects were preserved, if only in 'a less conspicuous part of the house', for some future time. That time came for Henry Moore in the early 1920s, when he saw these self-same objects in the Ethnographical Galleries:

The displays for me were wonderful; works were packed together in the glass show-cases, often jumbled up, and so on every visit there always seemed to be new things to discover. I was particularly interested in the African and Pacific sculptures and felt that 'primitive' was a misleading description of them, suggesting crudeness and incompetence. It was obvious to me that these artists were not trying – and failing – to represent the human form naturalistically, but that they had definite traditions of their own. The existence of such varied traditions outside European art was a great revelation and stimulus. I used to draw many of these carvings, sometimes on any scraps of paper I had with me, sometimes in sketchbooks. And, of course, some of these carvings influenced my own work later.[7]

A fundamental purpose of museums is to hold objects to await their moment, and while some were dismissed or even patronized in the British Museum's early years, for the Ethnographical Collections that moment came in the late nineteenth and early twentieth centuries for artists including Jacob Epstein and Henry Moore. In the 1970s and 1980s Eduardo Paolozzi (1924–2005) explored the Museum's Ethnography Department in the Museum of Mankind, and created his exhibition *Lost Magic Kingdoms and Six Paper Moons from Nahuatl* (1985); Grayson Perry (b.1960) brought together examples of his own work and objects from the Museum to make the exhibition *The Tomb of the Unknown Craftsman* (2012): 'a memorial to makers and builders, all those countless un-named skilled individuals who have made the beautiful man-made wonders of history'. His show reversed the convention of a contemporary artist responding to a museum's collection, and, as Philip Attwood, Keeper of Coins and Medals, observed at the time, 'Perry selected and juxtaposed objects in a way that none of those of us working here would ever have conceived. The exhibition will be quite unlike anything the British Museum has put on in the past.'

OVERLEAF
Arthur Conan Doyle's application for a reading ticket to the
Reading Room, 1891.

A43168

No. 1659

6 months.

Apr. 7-10. 91

BRITISH MUSEUM,

April 2 1891.

The Principal Librarian of the British

Museum begs to inform _Dr A. C. Doyle_
Arthur Conan

that a Reading Ticket will be delivered to

him on presenting this Note to the

Clerk in the Reading-room, within Six

Months from the above date.

N.B.—Persons under twenty-one years of age
are not admissible.

W B & L (66ᴘ)—2789—5000-1-90

READING ROOM.

TO THE PRINCIPAL LIBRARIAN OF THE BRITISH MUSEUM.

SIR,

I hereby make application to you for admission to the Reading Room of the British Museum, and I append the particulars required by the regulations of the Trustees.

I AM ABOVE TWENTY ONE YEARS OF AGE.

Purpose for which
admission is required } *Information on subject of 30 years War & Puritan movement*

Name *Alonan Doyle. MD.*

Address *23 Montague Place.*

Profession or
Occupation } *Physician*

Date *April 1st* 189*1*.

Admission is not given to persons under twenty-one years of age unless it can be shown that they are engaged in literary work requiring research. Study for examinations is not considered to give a claim for relaxation of the rule of exclusion.

R & S (38,662a) 2000 1—89 [TURN OVER.

So rich and estimable an institution as the British Museum inevitably became as much an object of interest as the objects contained within. This, of course, reveals a problem. The British Museum was, as we have seen, an early subject for diarists, belle-lettristes and even cartoonists. *The British Museum in Fiction: A Check-List*, compiled by Edward F. Ellis in 1981, contains references to the work of over 1,300 authors writing in English who have entwined the British Museum into their stories. Together they indicate how indelibly this institution has impressed itself on literature and the life it reflects. In Dickens's *Sketches by 'Boz'* (1836) we find the Museum to be the haunt of the 'shabby-genteel', and in Benjamin Disraeli's novel *Endymion* (1880) 'the gentleman from the British Museum made some remarks about the mode in which the ancient Egyptians moved masses of granite'. This must have been Layard or Newton. Thomas Hardy evokes the services of the Museum, most notably in *Tess of the d'Urbervilles* (1891) when the Reading Room was the natural source of information for the socially ambitious Simon Stoke when in search of 'extinct, half-extinct, obscured, and ruined families'. He found what he wanted.

On and on across the late nineteenth and twentieth centuries the British Museum serves a literary community: E. Nesbit, in her *Story of the Amulet* (1906), George Gissing, Arthur Conan Doyle, Henry Rider Haggard, Virginia Woolf, Paul Gallico, Angus Wilson (Superintendent of the Reading Room) and David Lodge, whose character Adam Appleby in *The British Museum is Falling Down* (1965) nearly sets the place on fire. Lodge gives his readers much to engage them, as Appleby sits at his desk in the Reading Room dreaming of English literature, Catholic teaching and birth control. From the 1960s until the 1990s the Reading Room was separated from the Entrance Hall by an enclosed

corridor, masking readers from the former courtyard beyond, which was by now the home of book stacks: 'He passed through the narrow vaginal passage, and entered the huge womb of the Reading Room,' writes Lodge.

* * *

More words, more than perhaps on any other group of related objects in the Museum, have been written about the Parthenon Sculptures, both as resonant historic objects and as objects of political debate, though these two categories are interdependent. Not only do the Sculptures represent the pinnacle of the collective human achievement that created the civilization of fifth-century BC Athens, but they are themselves a supreme statement of cultural production in the service of a state. Carved by a team of consummate sculptors under tight cultural, religious and managerial control, they are the defining product of an age. Their sculptors voice the religious and political imperatives of their masters and the myths and ethics that guided them. The importance of the Sculptures for world culture and the circumstances of their acquisition by the British Museum will remain a hot political topic until such time as their ownership is settled to the satisfaction of all parties, which includes humanity as a whole. There is an argument here because two reasonable but irreconcilable positions come head to head in the Parthenon Sculptures: the ownership of national heritage rooted in emotion and memory (Greece), and cultural resonance on a world scale mixed with the perception of an enduring duty of care (British Museum). The irony, and opportunity, is that these positions are interchangeable. While both sides exhibit a sense of entitlement, the argument will be resolved only when the parties are able to acknowledge this mirroring and overcome the embedded asymmetry: a nation is negotiating with an institution. A key to the dispute may have something to do with creating

OVERLEAF
The Parthenon Marbles as displayed at the British Museum from the mid-twentieth century.

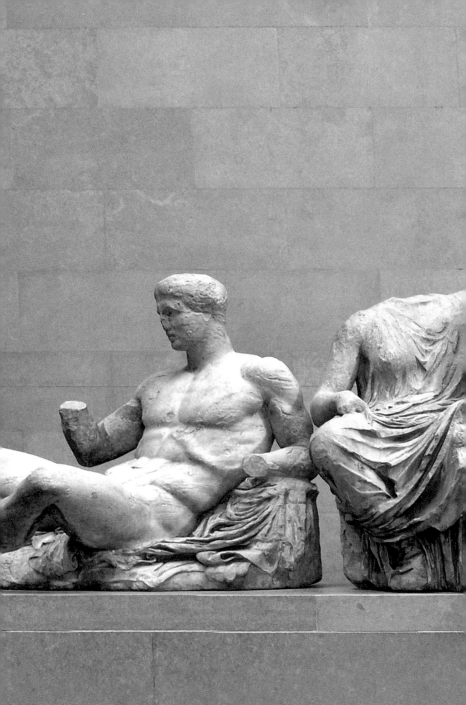

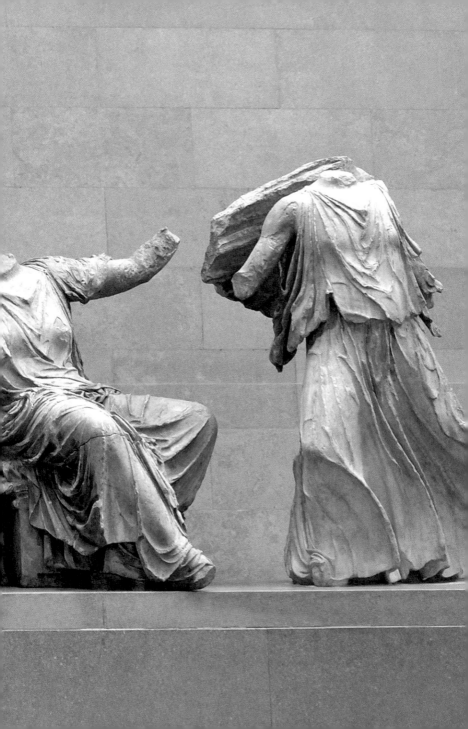

together through our own resources a unified, prosperous and peaceful Europe. The Parthenon Sculptures are a complex symbol of unity, prosperity and peace, which requires an understanding settlement.

These are the bland words that the Trustees have published to describe the part the Parthenon Sculptures play in the work of the British Museum:

> The British Museum tells the story of cultural achievement throughout the world, from the dawn of human history over two million years ago, until the present day. The Parthenon Sculptures are a significant part of that story. The Museum is a unique resource for the world: the breadth and depth of its collection allow a global public to examine cultural identities and explore the complex network of interconnected human cultures… The Parthenon Sculptures are a vital element in this interconnected world collection. They are a part of the world's shared heritage and transcend political boundaries.

Two hundred years, almost to the day, after the Parthenon Sculptures entered the British Museum an infinitely more modest artefact, in terms of material, weight and scale, passed through the forty-four columns. This was a simple Christian cross, with a curve that might be considered elegant, if that observation were not out of place, fashioned from the wood of a broken boat. It was made by Francesco Tuccio, the carpenter of the small island of Lampedusa, off the southern coast of Italy, who with his fellow islanders witnessed the arrival of thousands of Eritrean and Somali migrants attempting to cross the Mediterranean from Libya in 2013 during the years of migration. The boat from which the Lampedusa Cross[8] was made foundered on 11 October 2013 with the loss of 311 lives. While more than 150 people were rescued, the event prompted Mr Tuccio to fashion crosses from the wreckage of this boat to mark each of the lives lost, as a symbol of salvation and hope for the future. This cross, made especially for the British

Museum at the request of Jill Cook, curator in the Department of Britain, Europe and Prehistory, was presented by Mr Tuccio in 2015. It holds a central place in the ethos and purpose of the British Museum. This is how it is described in the Museum's records on its website:

> Wooden cross of Latin type made from pieces of a boat that was wrecked off the coast of Lampedusa, Italy on 11 October, 2013. The vertical and horizontal pieces are joined with a cross halved joint. The cross piece retains scuffed blue paint on the front, upper and lower surfaces. The front of the vertical section has layers of damaged paint. The base coat is dark green which was covered with a beige colour then painted orange. The sides and back are planed down to the timber surface. There is a small hole for suspension on the back of the vertical near the top. A fragment of an iron nail survives at the top in the right side of the cross piece. The back of the cross piece is signed F. Tuccio, Lampedusa.

The unemotional crispness of this description creates the necessary distance required in describing physical state, much as a doctor might adopt when diagnosing disease or injury. Nothing of the adventure and excitement of acquiring objects for the Museum emerges from this text. As a curator it is part of Jill Cook's job to find objects that tell stories, and through their resonances enhance the collection. Hearing how the people of Lampedusa responded to the 2013 tragedy made Cook think about what her department should collect to reflect the story of migration and humanitarian disaster that is having such a major impact on European society and politics. What objects, in two hundred years' time, would the Museum hold to acknowledge this momentous period? Cook realized that Francesco Tuccio's humane initiative was the key. She describes the sequence of events:

> Then we had to find him and this we did via the telephone directory and a couple of 'phone calls. My initial enquiry to him

was would he make a cross and how much would it cost? His answer was yes and nothing. The rest is history. I asked a colleague who was attending a conference in Sicily if he could meet the ferry from Lampedusa to pick up the cross, but such complex arrangements were unnecessary, because Mr Tuccio had already put it in the post. When it arrived, I showed it to Neil MacGregor, who immediately wanted to publicise it as the last object acquired during his directorship – it might not otherwise have been noticed. He has since added that the Lampedusa Cross is an object that humbles a great institution.[9]

The Parthenon Sculptures represent the cultural expression of a civilization at its peak with who knows what depths of stress and discord within; the Lampedusa Cross, a diminutive and modest object of minimal cost and simple craftsmanship, is likewise a cultural expression of an advanced civilization – our own – which directly confronts the stresses and discords of the twenty-first century. Though separated by voids in terms of material, influence and market value (if such a figure could ever be imagined for either), the Parthenon Sculptures and the Lampedusa Cross are of equal significance and emotional power in the story of the British Museum.

* * *

The British Museum has evolved directly out of cross-currents in eighteenth-century thought: Baconian empiricism and Lockean humanism, both of which contributed to the European Enlightenment. The Enlightenment is the lens through which we have come to observe and consider the past. It has spawned not only twentieth-century encyclopaedias and the twenty-first-century *Wikipedia*, all of which grew from Diderot's *Encyclopédie*, but everything from primary schools to universities, research

The Lampedusa Cross, 2015, by Francesco Tuccio.

institutes, think-tanks and a free press. Conversely, museums as a whole are at risk in totalitarian societies, as the depredations of museum and art collections by Napoleon in the late eighteenth and early nineteenth century, the Nazis in the twentieth century, and Islamist fundamentalists in the twenty-first have shown. As an Enlightenment product, museums must themselves evolve, and lead as well as mirror society as it changes.

In the same way that museums can be the focus of authoritarian attrition, so they are natural arenas for liberal expression and protest. In 2016 the British Museum was the scene of demonstrations against BP, the sponsor of the exhibition *Sunken Cities*. Protesters from Greenpeace dressed as mermaids occupied the Great Court, while others hung banners from the columns on the façade naming cities and small towns that would be inundated as a result of climate change – New Orleans, Boscastle, Manila, Maldives, Hebden Bridge. Like it or not the British Museum is part of such a wide-ranging political and environmental debate that discord over the Parthenon Sculptures is by comparison a playground squabble over toys.

From the day they entered the British Museum, the place where cultures meet, it was inevitable that political debate over the future of the Parthenon Sculptures would one day reach a crisis. As signifiers of public expression, penny lapel badges demanding Votes for Women or Gay Rights are as important acquisitions for the Museum, as is the Lampedusa Cross which marks both a high point and a low in humanity's understanding of itself. The purchase and display, with little or no public fuss, in 1999 of the Warren Cup, a first-century AD Roman silver cup depicting male same-sex activity, suggests that one crisis at least had passed. Only fifty years earlier, one-fifth of the Museum's own timespan, the Warren Cup would have had a very different reception. The exhibition *Collecting the 20th Century*, mounted in 1991 to mark David Wilson's retirement as director, presented

The Warren Cup, 15 BC–AD 15. This silver cup is decorated
with images of male same-sex acts and was purchased by the
British Museum for £1.8 million in 1999.

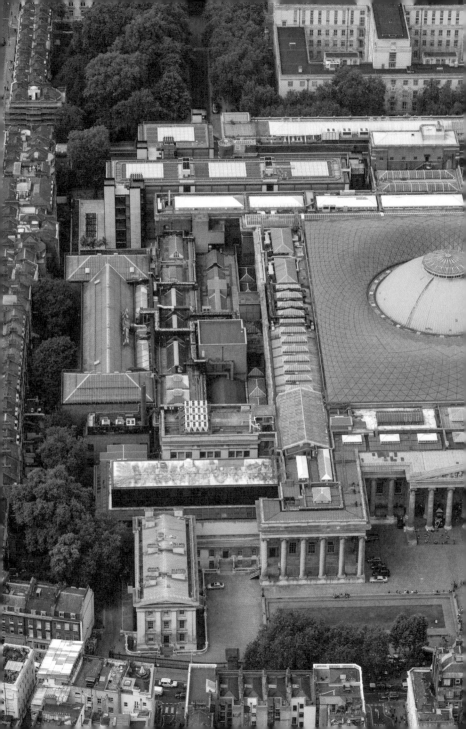

for the first time a clear appraisal of the Museum's responsibility to look forwards as well as back. Here were shown not only the Ethnography Department's acquisitions of paper effigies of modern objects such as a telephone, typewriter and a motorbike of the kind usually burned in Chinese funeral ceremonies, but also jewellery donated by Professor and Mrs Hull Grundy, and twentieth-century items of silver, glass and ceramics from around the world. These new acquisitions by the Medieval and Later Antiquities Department reflect the continuity of design practice, and the currents of use, form and pattern as they return across the centuries.

From the air – and at night from the London Eye or from an aeroplane cruising over London to land at Heathrow – the new roofscape enclosing the Great Court is a bright celestial doughnut shining among the pattern of London rooftops. By day the top of the Reading Room dome bobs in a clear blue sea, a lazy buoy caught in a lagoon. The view upwards from within reveals on a sunny day not aeroplanes but flights of London pigeons resting within its grid of glass triangles. Some of the birds now and then lift off to add brisk movement to the shifting patterns of their kind. The newly revitalized British Museum, its Great Court echoing with a constant hubbub and swirling movement of hundreds of people, has lost nothing of the startling effect it had on its first visitors, those who came upon it as Shelley's 'travellers in an antique land' to explore, as Neil MacGregor expressed it 250 years later, 'the interlocking stories of humanity'.[10]

Fourteen years after the Great Court was revealed for the first time since the 1850s, the Museum's World Conservation and Exhibitions Centre was constructed. Opened in 2014, this had been inserted neatly into the vacant space at the northwest corner of the Museum between the eighteenth-century terraces of Montague Place and the Duveen Gallery, and the range of buildings that first completed the Museum's rectangular form in

PREVIOUS PAGE
An aerial view of the British Museum.

the 1840s. Thus the Museum grows its layers as a tree grows its rings, and as decades go by the organism shifts and changes, with its conservation, storage and display functions being constantly refreshed and updated.

The quantity of objects in the British Museum – around 8 million – approaches the population of London; and with all its contributory rivers the Museum mirrors the nature of Britain as a whole. Hans Sloane directed that his collection 'be preserved entire without the least diminution or separation... for the use and benefit of the public'. More than 250 years on, with countless other collections joining Sloane's, the British Museum honours its founder's direction. Equally, it follows the poet T. S. Eliot's injunction, in *The Dry Salvages*: 'consider the future and the past with an equal mind'.

OVERLEAF
The Great Court with the Round Reading Room, 2011.

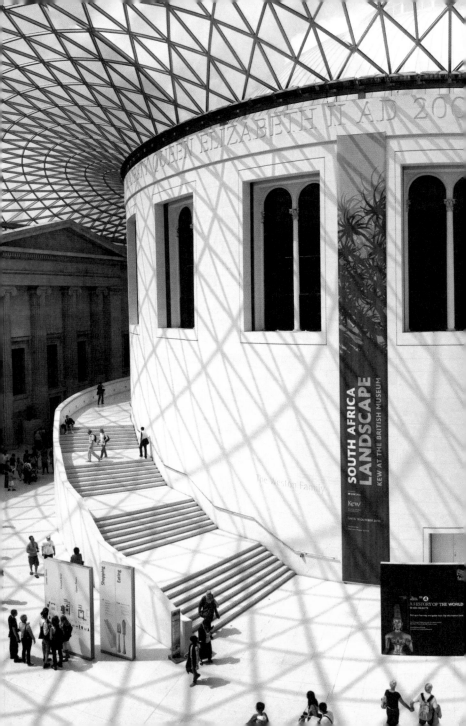

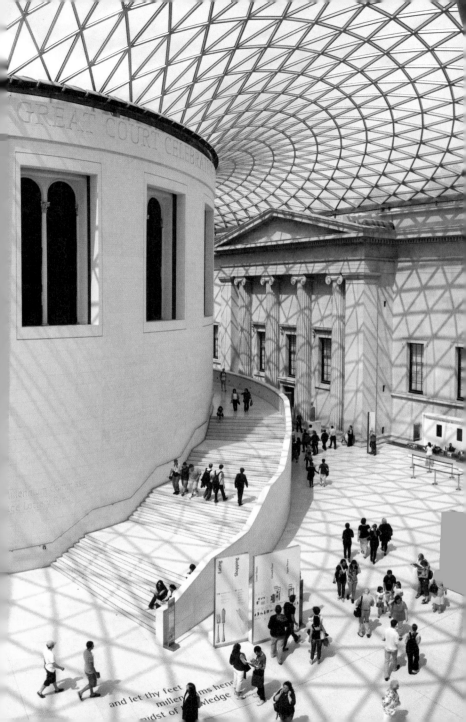

Appendices

The last will and testament of Sir Hans Sloane
Signed and sealed 9 October 1739

Transcribed from the version published by John Virtuoso,
near Crane Court, Fleet Street, 1753.

I Sir Hans Sloane, of the parish of St George, in Bloomsbury, in
the county of Middlesex, doctor in physic and baronet, being
in health of body and mind (thanks be to God)... do make this
my last Will and Testament... Whereas from my youth I have
been a great observer and admirer of the wonderful power, wis-
dom and contrivance of the Almighty God, appearing in the
works of his Creation; and have gathered together many things
in my own travels or voyages, or had them from others, especially
my ever honoured late friend William Courten Esq; who spent
the greatest part of his life and estate in collecting such things, in
and from most parts of the earth, which he left me at his death...
And whereas I have made great additions of late years as well
to my books, both printed as manuscript, and to my collections
of natural and artificial curiosities, precious stones, books and
dryed samples of plants, miniatures, drawings, prints, medals and
the like, with some paintings concerning them, now placed in my
house and gardens, amounting in the whole to a very great sum
of money, reckoning them at first costs to at least fifty thousand
pounds. Now desiring very much these things tending many
ways to the manifestation of the glory of God... may remain to-
gether and not be separated, and that chiefly in and about the city
of London, where I have acquired most of my estates, and where
they may by the great confluence of people be of most use. Now

I do give and devise… upon this special trust and confidence, that [my executors] shall as soon as may be after my decease, sell, and dispose of the same to be settled for the public uses aforesaid, at the rate of twenty thousand pounds of lawful money of Great-Britain… to his majesty [King George II] … But if his majesty shall not think fit to accept of the same within six months after such overture made, then my will is, that they be offered at the same price to the president, council and fellows of the Royal Society of London… and upon their refusal to the chancellor and scholars of the University of Oxford, and upon their refusal, then successively to be offered to the College of Physicians at Edinburgh, the Royal Academy of Sciences at Paris, that at Petersburg, Berlin and Madrid, who have done me the honour to make me one of their members. And my Will is that every one of them shall have one month's time… for the acceptance of such offer.

Extract from the *London Magazine*,
July 1748, pp. 317–19

*In which the Prince of Wales
expresses his opinion.*

The prince took a chair and sat down by the good old gentleman some time, when he expressed the great esteem and value he had for him personally, and how much the learned world was obliged to him for his having collected such a vast Library of curious books and such immense treasures of the valuable and instructive productions of nature and art. Sir *Hans'* house forms a square of above 100 feet each side, inclosing a court; and 3 frontrooms had tables set along the middle, which were spread over with drawers filled with all sorts of precious stones in their natural beds, or state, as they are found in the earth, except the first, which contained stones formed in animals, which are so many diseases of the creature that bears them; as the most beautiful pearls, which are but warts in the shell fish; the *Bezoar's* concretions in the stomachs, and stones generated in the kidneys and bladders, of which man woefully knows the effects; but the earth in her bosom generates the verdant *emerald*, the purple *amethyst*, the golden *topaz*, the azure *sapphire*, the crimson *garnet*, the scarlet *ruby*, the brilliant *diamond*, the glowing *opal*, and all the painted varieties that *Flora* herself might wish to be decked with; here the most magnificent vessels of *cornelian, onyx, sardonyx,* and *jasper,* delighted the eye, and raised the mind to praise the great Creator of all things.

When their royal highnesses had viewed one room and went into another, the scene was shifted; for when they returned, the same tables were covered for a second time with all sorts of *jewels*, polished and set after the modern fashion; or with *gems* carved or engraved, the stately and instructive remains of antiquity. For the third course, the tables were spread with *gold* and *silver ores*, with the most precious and remarkable ornaments used in the *habits* of man, from *Siberia* to the *Cape of Good Hope*, from *Japan* to *Peru*, and with both ancient and modern coins and medals in gold and silver, the lasting monuments of historical facts; as those of a *Prusias*, king of *Bithynia* who betrayed his allies; of an *Alexander*, who, mad with ambition, overran and invaded his neighbours; of a *Caesar* who enslaved his country to satisfy his own pride; of a *Titus*, the delight of mankind; of a pope, *Gregory XIII*, recording on a silver medal his blind zeal for the cause of *religion*, in perpetrating thereon the *massacre* of the *protestants* in *France*; as did *Charles IX*, the then reigning king in that country: and here may be seen the coins of a king of *England* crowned at *Paris*; a medal representing *France* and *Spain*, striving which should first pay their obeisance to *Britannia*; others shewing the effect of popular rage, when overmuch oppressed by their superiors, as in the case of the *De Witts* in *Holland*; the happy deliverance of *Britain* by the arrival of king *William*, the glorious exploits of the duke of *Marlborough*, and the happy arrival of the present illustrious *royal family* amongst us.

The gallery, 110 feet in length, presented a most surprizing prospect; the most beautiful *corals*, *crystals*, and figured stones; the most brilliant *butterflies* and other insects; *shells* painted with as great a variety as the precious stones, and feathers of *birds* vying with gems; here the remains of an *Antediluvian* world, excited the awful idea of that great catastrophe, so many evident testimonies of the truth of *Moses's* History; the variety of animals shews us the great beauty of all parts of the creation.

Then a noble vista presented itself thro' several rooms filled with books; among them many hundred volumes of dried plants; a room full of choice and valuable manuscripts; the noble present sent by the present French king to Sir *Hans*, of his collections of paintings, medals, statues, palaces, &c. in 25 large Atlas volumes; besides other things too many to mention here.

Below stairs some rooms are fitted with the curious and venerable antiquities of *Egypt*, *Greece*, *Hetruria* [*sic*], *Rome*, *Britain*, and even *America*; others with large animals preserved in the skin; the great *Saloon* lined on every side with bottles filled with spirits, containing various animals. The halls are adorned with the horns of divers creatures, as the double horned *rhinoceros* of *Africa*, the fossil deer's horns from *Ireland*, 9 feet wide; and with weapons of different countries, among which it appears that the *Mayalise*, and not our most *christian* neighbours the *French*, had the honour of inventing that butcherly weapon the *bayonet*. Fifty volumes in folio would scarce suffice to contain a detail of this immense *Museum*, consisting of above 200,000 articles.

Their royal highnesses were not wanting in expressing their satisfaction and pleasure at seeing a collection, which surpassed all the notions or ideas they had formed from even the most favourable accounts of it. The *prince* on this occasion shewed his great reading and most happy memory; for in such a multiplicity, such a variety of the productions of nature and art, upon any thing being shewn him he had not seen before, he was ready in recollecting where he had read of it; and upon viewing the antient and modern medals he made so many judicious remarks, that he appeared to be a perfect master of history and chronology. He expressed the great pleasure it gave him to see so magnificent a collection in *England*, esteeming it an ornament to the nation; and his sentiments, how much it must conduce to the benefit of learning, and how great an honour will redound to *Britain*, to have it established for publick use to the latest posterity.

Codicil to Sir Hans Sloane's will
Signed and sealed 10 July 1749;
resealed 26 December 1751

In which Sir Hans Sloane changes his mind.

Having had from my youth a strong inclination to the study of plants, and all other productions of nature; and having through the course of many years with great labour and expense, gathered together whatever could be procured either in our own or foreign countries that was rare and curious; and being fully convinced that nothing tends more to raise our ideas of the power, wisdom, goodness, providence, and other perfections of the Deity, or more to the comfort and well-being of his creatures than the enlargement of our knowledge in the works of nature, I do Will and desire that... my collection in all its branches may be, if possible, kept and preserved together whole and intire in my manor house, in the parish of Chelsea, situate near the physic garden, given by me to the company of apothecaries for the same purposes... I do give, devise and bequeath unto [*here he names forty-eight trustees, listed in Appendix 4*] ... all that my collection or museum, at, in, or about my manor house at Chelsea aforesaid, which consists of too great a variety to be particularly described. But I mean all my library of books, drawings, manuscripts, prints, medals and coins, ancient and modern, antiquities, seals &c, cameos and intaglios &c, precious stones, agates, jaspers &c, vessels &c of agate, jasper &c, crystals, mathematical instruments, drawings and pictures, and all other things in my said collection or museum, which are more particularly described, mentioned

and numbered, with short histories or accounts of them, with proper references in certain catalogues by me made, containing thirty-eight volumes in folio, and eight volumes in quarto, except such framed pictures as are not marked with the word 'collection' to have and to hold to them and their successors and assigns for ever; to the intent only that the same and every part and parcel of my said collection or museum may be vested in the said Right Honourable and Honourable, and other persons upon the trusts, and for the uses and purposes, and subject to the several limitations and directions hereafter particularly specified... that the said collection may be preserved and continued intire in its utmost perfection and regularity... placing the same under the direction and care of learned, experienced and judicious persons... I do earnestly desire that [*here thirty-four official posts from the king down and peers of the realm, listed in Appendix 4*] will condescend so far as to act and be visitors of my said museum or collection... to enter my said collection at any time or times, to peruse, supervise and examine the same and the management thereof; and to visit, correct and reform from time to time as there may be occasion... And my will is... that the said trustees... do make their humble application to his majesty or to parliament... in order to pay the full and clear sum of twenty thousand pounds... unto my executors... in consideration of the said collection or museum: it not being, as I apprehend or believe, a fourth of their real and intrinsic value... To the end, [my manor house at Chelsea] may be absolutely vested in the said trustees, for preserving and continuing my said collection or museum in such a manner as they shall think most likely to answer the public benefit by me intended.

The said Trustees... do and shall... meet together from time to time, as often as shall be thought fit, and there make, constitute and establish (to be afterwards ratified and approved by the visitors)... such statutes, rules, and ordinances, and to make and

appoint such officers and servants for the attending, managing, preserving and continuing of my said museum, or collection and premises, for ever, with such salaries, payments, or allowances to them respectively, as shall seem meet and necessary.

And I do hereby declare... that my said museum or collection... may be, from time to time, visited and seen by all persons desirous of seeing and viewing the same... that the same may be rendered as useful as possible, as well towards satisfying the desire of the curious, as for the improvement, knowledge and information of all persons.

Individuals and ex officio posts named in the 1751 codicil as Trustees and Visitors to Sir Hans Sloane's Museum

Trustees

Rt Hon. Charles Sloane Cadogan; Hans Stanley; William Sloane; Rev. Sloane Elsmere DD, Rector of Chelsea; Martin Folkes, President of the Royal Society; Sir Paul Methuen; James West, Treasurer of the Royal Society; Samuel Clarke; Hon. Richard Arundell; Joseph Andrews; Joseph Ames; Henry Baker; Rev. James Bradley DD, Astronomer Royal; Sir Thomas Burnet; Peter Collinson; Sir John Evelyn; John Fuller of Sussex; Rev. Steven Hales, DD; Theodore Jacobson; Smart Lethieullier; Sir James Lowther; George Littleton; Rev. Charles Littleton DD, Dean of Exeter; Rev. Henry Miles DD; David Papillon; Sir George Saville; Sir Hugh Smithson; Rev. Thomas Shaw DD; Charles Stanhope; Rev. William Stukeley; James Theobald; Sir Peter Thompson; Hon. Horatio Walpole, jun.; Hon. Philip Yorke; Sir William Codrington; Henry Gough; Charles Gray; General James Oglethorpe; John Ranby; George Bell; Rt Rev. George [Lavington], Lord Bishop of Exeter; Rt Rev. Zachary [Pearce], Lord Bishop of Bangor; Rt Hon. Edward Southwell; Sir William Heathcote; Sir John Heathcote; John Milner; James Empson; William Watson.

Ex officio Visitors

The King; the Prince of Wales; William, Duke of Cumberland; the Archbishop of Canterbury; the Lord High Chancellor; the Lord President of the Council; the Lord Privy Seal; the Lord Steward of his Majesty's Household; The Lord Chamberlain; Charles, Duke of Richmond; John, Duke of Montague; Holles, Duke of Newcastle; John, Duke of Bedford; the two principal Secretaries of State; Rt Hon. John Earl of Sandwich; the Lord High Admiral or the First Lord Commissioner of the Admiralty; the Lord High Treasurer; the Chancellor of the Exchequer; the Lord Chief Justice of the King's Bench; the Lord Chief Justice of Common Pleas; the Lord Chief Baron of the Exchequer; the Lord Bishop of London; the Lord Bishop of Winchester; Archibald, Duke of Argyll; Henry, Earl of Pembroke; Philip, Earl of Chesterfield; Richard, Earl of Burlington; Henry, Lord Montford; The Speaker of the House of Commons; Lord Charles Cavendish; Charles, Lord Cadogan; John, Earl of Verney; George, Lord Anson.

The British Museum trustees write to the Treasury, 1832

*In which the trustees
make it clear to the Treasury that
they need more money to complete the north,
west and east Wings, and they need it now.
From Trustees' meeting minutes, 14 January 1832*

The Trustees feel the method of proceeding with the new building at the Museum to be a matter which so strongly affects both the interests and convenience of Literary men and the safety of the literary treasures committed to the charge of the Trustees, that they think it their duty to press again upon your Lordships' attention some of the more important circumstances which induce the Trustees to desire the commencement of the North side in preference to the final completion of the wings which have already been commenced. The east wing is indeed at present complete in all its material parts. It will only require the addition of the balustrade of the staircase at its Northern extremity. The question therefore is as to the priority to be given to the final completion of the West Wing, or the commencement of the new North Side. In order to judge of this question it will be necessary for Your Lordships to understand clearly the present state of the New Buildings, and the purposes to which certain parts both of the old and the New buildings are applied or designed.

The West Wing may be considered as divided into three portions,

1 A completed portion comprising two Galleries connected with the body of the wing;

2 A portion of which the shell only has been raised;

3 A portion not yet commenced, and for which having been considered a part of the new buildings not immediately necessary, the Trustees have made no arrangements with a view to its early execution.

By the completion of the first part a receptacle has been provided for the Elgin and Phigaleian Marbles, and the Trustees having now caused these marbles to be removed thither from the temporary shed in which they had remained for several years, exposed to accidents from inclement weather are now relieved from all anxiety as to the preservation of these precious remains of ancient art.

With regard to the second or northern portion of the new West Wing, of which portion the shell is already raised, the Trustees feel that it would be desirable to finish it with as little delay as possible, and they wish to defer its completion only in consideration of the urgent necessity for the new North side. This portion of the Building, it should be remarked, is in a state in which it will suffer no injury from the weather.

The site of the third or south portion of the west wing, which has not yet been commenced, is a great measure occupied by the Building raised about twenty-five years ago for the Antiquities of the Museum, and before the foundation of the south part of the west wing can be conveniently laid the Building occupying the site must be taken down. This building is substantial and fire-proof, and though it does not afford space for the proper display of its contents, it is sufficient for their safe preservation. It contains the Egyptian Marbles and Antiquities; the Townley and general collection of Marbles; The Hamilton Collection of Vases, and the chief part of the Bronzes and Gems. In case of this build-

ing being taken down previously to the completion of the front of the New Museum no space could possibly be found for the exhibition of these important collections.

A more serious difficulty would arise from the circumstance that the room in which the Coins and Medals are deposited is situated in this Building, and as the Medal Room, in order to provide sufficiently for the safety of its contents, must be constructed in a peculiar manner, it would be impossible to be responsible for the custody of this part of the Museum Collections if the present Medal Room were destroyed before a new one was prepared for the reception of its Cabinets.

Upon these grounds the Trustees are clearly of the opinion that the Southern front of the West Wing must be deferred until the other parts of the Museum are completed.

The urgent necessity for the new North Side arises, as has been fully stated to your Lordships in the letter of the Trustees of the 15 December, from the want of increased accommodation of the Readers, the want of more ample space for the books and the insecurity of the Building in which the Library is deposited.

The want of accommodation for the increasing number of Readers may readily be conjectured by Your Lordships from the facts that upwards of Forty Thousand visits are now annually made to the Library of the British Museum for the purpose of research, and that the increase of students is so rapid, that which in a week of March 1830 they amounted to 564, in a week of April 1831 they were 650 and in a week of December no less than 839.

As the Trustees are aware that it is impossible for Your Lordships to be made acquainted with all the bearings and details of the case by means of a letter, they have directed Mr Smirke the Architect employed upon the new Buildings of the Museum together with the Principal Librarian and the Secretary of the Establishment to produce to Your Lordships, if Your Lordships should think it necessary, the Plans of the Buildings, and to be prepared

to offer any explanations which Your Lordships may require.

Upon a review of all the circumstances Your Lordships will, it is trusted, sanction the immediate commencement of the North side of the Museum Buildings, as proposed by the Trustees in their letter of the 15th December.

I have the honor [*sic*] to be, &c &c.

Timeline

1660
Hans Sloane is born in Killyleagh, Ireland.

1707
Sloane publishes *A Voyage to the Islands*.

1739
Sloane makes his will.

1742
Sloane moves his collection to Chelsea Manor.

1748
The Prince of Wales visits Sloane and his collection.

1749
Sloane signs the codicil to his will.

1753
Sloane dies; the British Museum Act receives royal assent.

1754
Montagu House is selected as the home for the British Museum.

1756
Gowin Knight is appointed Principal Librarian; further staff are appointed.

1757
Gift of the Old Royal Library by George II.

1759
The British Museum opens to the public.

1761
Edmund Powlett's *General Contents of the British Museum* is published.

1771
Ethnographical material is brought to the Museum from Captain Cook's voyages into the Pacific.

1772
Sir William Hamilton's collection is purchased.

1775
Captain Cook's collection of 'artificial curiosities from the South Seas' is acquired.

1778
Van Rymsdyk's *Museum Britannicum* is published; South Sea Room is opened.

1780
The Gordon Riots. The York Regiment is stationed in the British Museum.

1799
The Cracherode bequest; the Hatchett collection of minerals is acquired; Joseph Planta becomes Principal Librarian.

1802
The Rosetta Stone arrives.

1804
The Dighton thefts begin.

1805
The Townley Collection is purchased.

1808
The Townley Wing is opened; the British Museum *Synopsis* is first published.

1810
The ticketing system of admission is abandoned.

1814
The Phigaleian Marbles are purchased.

1815
Battle of Waterloo.

1816
The Parthenon Sculptures are purchased by the government, and vested in the British Museum.

1817
Robert Smirke is appointed architect to the British Museum by the government. His first building is the temporary gallery for the Parthenon Marbles. The head of Ahmenhotep III is removed from Thebes.

1818
Gas light is introduced into the Montagu House courtyard.

1821
Robert Smirke presents his plans for the expansion of the Museum.

1823
Library of King George III is given to the Museum by George IV; construction of the King's Library begins; it is completed in 1827.

1824
The Payne Knight bequest is received.

1826
Construction of West Wing begins.

1828
Oil paintings are transferred to the National Gallery.

1831
The Lewis Chessmen are purchased.

1832
The Townley Venus is damaged by a careless student.

1834
Robert Smirke's West Wing is completed.

1836
The select committee's report on the British Museum is published.

1838
The New North Wing is completed.

1841
Work on Robert Smirke's south façade begins; Townley Wing is demolished.

1842
Montagu House demolition begins; the Copyright Act is passed.

1845
Demolition of Montagu House is completed; Layard's Assyrian excavations begin; the Portland Vase is smashed by a visitor; it is subsequently repaired.

1846
The south façade is completed. Sydney Smirke takes over as architect to the British Museum.

1847
Thomas Grenville's bequest of his 20,000-volume library is received.

1851
Augustus Wollaston Franks is appointed Assistant Keeper of Antiquities.

1853
Excavations at Nineveh and Nimrud begin.

1854
Construction of Round Reading Room begins.

1856
Antonio Panizzi becomes Principal Librarian; Charles Roach Smith collection of British archaeology is acquired.

1857
Michael Faraday reports on the conservation of the Parthenon Marbles; the Round Reading Room is opened; 'Battersea shield' is acquired.

1865
The first Museum restaurant is opened; the Henry Christy bequest is received.

1873
Construction of the Natural History Museum in South Kensington begins.

1881
The Natural History Museum opens in South Kensington.

1890
The Museum is fully lit by electricity.

1895
The Museum acquires an additional five and a half acres of land in Bloomsbury.

1897
Death of A. W. Franks; his bequest is received by the Museum.

1902
An act of Parliament allows newspapers and magazines to be moved out of Bloomsbury.

1904
Construction of the Edward VII Building begins.

1914
The Edward VII Building is opened.

1920
The Museum research laboratory is established.

1922
Excavations at Ur begin.

1926
Campbell Dodgson gives his collection of twentieth-century prints and drawings to the Museum.

1933
The *Codex Sinaiticus* is purchased from the Soviet government.

1936
Construction begins on the Duveen Gallery.

1939
Installation of the Parthenon Sculptures begins and is curtailed in the Duveen Gallery; the Sutton Hoo ship burial is discovered. The precautionary removal of collections into store begins.

1941
The Museum is damaged by incendiary bombs.

1945
The Portland Vase is purchased, following a period of nearly 200 years on loan to the Museum.

1956
A new site for the British Museum library, across Great Russell Street, is proposed.

1963
The formal separation of the British Museum and the Natural History Museum. The tradition of family trustees is abandoned.

1967
The proposed Great Russell Street site for the library is abandoned.

1970
The Museum of Mankind opens in Burlington Gardens.

1972
The Treasures of Tutankhamun exhibition takes place.

1973
The British Library is constituted within the British Museum.

1974
Museum entry charges are imposed, and abandoned within four months.

1982
The foundation stone for the new British Library, designed by Colin St John Wilson, is laid at St Pancras.

1987
Works on paper in the Turner Bequest are transferred to the Tate Gallery.

1988
The repaired Portland Vase is taken apart and reassembled.

1994
Foster and Partners are appointed architects of the Queen Elizabeth II Great Court.

1995
The Edward Wharton-Tigar collection of over one million cigarette cards are bequeathed to the Museum.

1997
The Museum of Mankind closes; the Round Reading Room is closed by the British Library.

1998
The British Library opens at St Pancras; construction begins in the Great Court.

1999
The Warren Cup is acquired.

2000
The Queen Elizabeth II Great Court is opened.

2003
The British Museum celebrates its 250th anniversary.

2010
A History of the World in 100 Objects radio series is broadcast.

2014
The World Conservation and Exhibitions Centre is opened.

2015
The Lampedusa Cross is accepted as a gift.

Acknowledgements and permissions

My thanks for advice, conversation and insight to Gaetano Ardito, Michael Baker, Charlotte Bullions, Frances Carey, Marjorie Caygill, Jill Cook, Kate Eustace, Francesca Hillier, Ian Jenkins, Claire Mayoh and Lindsay Stainton. I am most grateful to the following for permission to make quotations: the Trustees of the British Museum, the Henry Moore Foundation, the University of Oxford, Bodleian Library, David Lodge and Sir David Wilson. Every effort has been made to contact copyright holders for permission to reproduce material in this book. In the case of any inadvertent oversight, the publishers will include an appropriate acknowledgement in future editions of this book.

Select bibliography

Altick, Richard, *The Shows of London*, Cambridge, Mass, 1978.

Carey, Frances, *Collecting the Twentieth Century*, London, 1991.

Caygill, Marjorie, *The Story of the British Museum*, London, 1981 and 2002.
———— *British Museum A–Z Companion*, London, 1999.
———— *The British Museum Reading Room*, London, 2000.
———— *The British Museum: 250 Years*, London, 2003.

Caygill, Marjorie and Date, Christopher, *Building the British Museum*, London, 1999.

Cowtan, Robert, *Memories of the British Museum*, London, 1872.

Crook, J. Mordaunt, *The British Museum: A Case-Study in Architectural Politics*, Harmondsworth, 1972.

Delbourgo, James, *Collecting the World: The Life and Curiosity of Hans Sloane*, London, 2017.

Edwards, Edward, *Lives of the Founders, and Notes of some Chief Benefactors and Organisers of the British Museum*, London, 1870, reprinted 1969.

Ellis, Edward F., *The British Museum in Fiction – A Check-List*, Buffalo, NY, 1981.

Griffiths, Antony (ed.), *Landmarks in Print Collecting*, London, 1996.

Harris, P. R., *A History of the British Museum Library 1753–1973*, London, 1998.

Jenkins, Ian, *Archaeologists and Aesthetes in the Sculpture Galleries of the British Museum 1800–1939*, London, 1992.

Miller, Edward, *That Noble Cabinet: A History of the British Museum*, London, 1973.

Moore, Henry, *Henry Moore at the British Museum*, London, 1981.

Sloan, Kim and Burnett, Andrew (eds.), *Enlightenment: Discovering the World in the Eighteenth Century*, London, 2003.

Wilson, David M., *The British Museum: Purpose and Politics*, London, 1989.
———— *The British Museum – A History*, London, 2002.

Notes

PROLOGUE

1 Virginia Woolf, *Jacob's Room*, 1922, ch. 9.

1 THE BEGININNGS

1 16 April 1691. E. S. de Beer (ed.), *The Diary of John Evelyn*, Oxford, 1955, vol. 5, p. 48.

2 W. H. Quarrell and Margaret Mare (trans. and ed.), *The Travels of Zacharias Conrad von Uffenbach*, London, 1934, p. 188.

3 Quoted in J. Mordaunt Crook, *The British Museum: A Case-Study in Architectural Politics*, Harmondsworth, 1972, p. 47.

4 *London Magazine*, 1748, vol. 17, pp. 317–19.

5 Ibid.

6 BM Cuttings and Extracts, CE115/3, ex BL Harl. 6850, f. 343.

7 BM Original Letters and Papers, vol. 1, doc. no. 1.

8 'Draught of an Acquittance to be executed by H Sloane Execrs / Agreed on 17 December 1753'. BM Original Letters and Papers, vol. 1, doc. no. 3.

9 BM Cuttings and Extracts, CE115/3, f. 22.

10 3 April 1753. BM Cuttings and Extracts, CE115/3, f. 22.

11 Katharine Eustace, 'The Key is Locke: Hogarth, Rysbrack and the Foundling Hospital', *British Art Journal*, 7.2, pp. 34–49.

2 THE BRITISH MUSEUM IN THE EIGHTEENTH CENTURY

1 BM Cuttings and Extracts, CE115/3, f. 30.

2 Surveyor's report, 3 July 1755. BM Original Letters and Papers, vol. 1. 'Green flock wallpaper': *Gentleman's Magazine*, June 1814. This might have been a later addition.

3 Quoted in Marjorie Caygill and
 Christopher Date, *Building the British
 Museum*, London, 1999, p. 13.

4 Gilbert White, *The Natural History of
 Selborne*, Letter 10, 4 August 1767.

5 Letter from Thomas Gray to Rev. James
 Brown, 8 Aug 1759, www.thomasgray.
 org/cgi-bin/display.cgi?text=tgal0344.

6 W. Hutton, *A Journey from
 Birmingham to London*, Birmingham,
 1785.

7 Tobias Smollett, *Humphry Clinker*,
 1771. Penguin Classics edition
 (ed. Jeremy Lewis), Harmondsworth,
 2008, pp. 115–16.

3 RUNNING THE MUSEUM IN THE
 EARLY NINETEENTH CENTURY

1 Captain Cook's Journal, 1774.

2 10th edition, 1816, p. 3, listing Cases XI
 to XXVI (i.e. fifteen cases).

3 *Penny Magazine*, 4 January 1834, p. 4.

4 Second Canto, verse 15.

5 Antony Griffiths (ed.), *Landmarks
 in Print Collecting*, London, 1996,
 pp. 49–50, and Appendix E.

4 DECADES OF RECONSTRUCTION
 1821–1846

1 David Bindman and Gottfried
 Riemann (trans. and eds), *Karl
 Friedrich Schinkel 'The English Journey'.
 Journal of a Visit to France and Britain
 in 1826*, New Haven and London, 1993,
 pp. 74 and 76.

2 Caygill and Date, Building the British
 Museum, p. 21.

3 Michael Baker, *The Samuel Bakers
 –Tradesmen of Kent in the 18th and
 19th centuries*, Bristol, 2009, pp. 17 ff.

4 J. Mordaunt Crook, *The British
 Museum: A Case-Study in Architectural
 Politics*, p. 210.

5 Legal ownership was not ceded to the
 National Gallery until 1866.

6 Letter from Thomas Donaldson to
 Robert Finch, 19 Aug 1825. Finch
 Papers, d. 5 ff. 160–1. Bodleian Library,
 University of Oxford.

7 www.british-history.ac.uk/commons-
 jrnl/vol85/pp376-386.

8 *The Times*, 13 April 1838.

5 THE MID-NINETEENTH
 CENTURY

1 Ozymandias, 1818.

2 W. Blanchard Jerrold, *How to see the
 British Museum in Four Visits*, London,
 1852, p. 143.

3 Hansard, 1 April 1833, vol. 16, col. 1341–2.

4 Humphry Davy, *Consolations in Travel*, London, 1830, pp. 24–7.

5 W. M. Thackeray, 'Nil nisi bonum', *Roundabout Papers; Works of Thackeray*, London, 1869, vol. 17, p. 364.

6 David M. Wilson, *The British Museum – A History*, London, 2002, p. 84.

6 **FROM THE VICTORIAN AGE INTO THE TWENTIETH CENTURY**

1 Michael Faraday to Henry H. Milman, 30 April 1857. Parliamentary Papers, 1857, session 2, vol. 24, pp. 149ff. Frank A. J. L. James, *The Correspondence of Michael Faraday*, London, 2008, vol. 5, no. 3278.

2 See Ian Jenkins, 'Cleaning and Controversy – The Parthenon Sculptures 1811–1939', *British Museum Occasional Papers*, no. 146, London, 2001, www.britishmuseum.org/pdf/4.4.1.2%20The%20Parthenon%20Sculptures.pdf.

3 Marjorie Caygill, *The Story of the British Museum*, London, 1981, p. 48.

4 Quoted David M. Wilson, *The British Museum – A History*, p. 188.

7 **THE TWENTIETH CENTURY**

1 In 2017 these were: Africa, Oceania and the Americas; Ancient Egypt and Sudan; Asia; Britain, Europe and Prehistory; Coins and Medals; Greece and Rome; Middle East; Prints and Drawings; Portable Antiquities and Treasure; Conservation and Scientific Research.

2 David M. Wilson, *The British Museum – A History*, p. 265.

3 Hansard, 10 April 1956, vol. 551. cc166–76.

4 Hansard, 13 December 1967, vol. 287, cc1114–240.

5 Letter from Thomas Kendrick to Stuart Piggott, urging him to apply for the vacant directorship of the BM. Quoted in Rupert Bruce-Mitford, 'Sir Thomas Downing Kendrick 1895–1979', in Michael Lapidge (ed.), *Interpreters of Early Mediaeval Britain*, London, 2002, p. 423.

6 Sir Frederic Kenyon, memo to the Royal Commission on the National Museums and Galleries, 1929, quoted in David M. Wilson, *The British Museum: Purpose and Politics*, London, 1989, p. 99.

7 James Hamilton, 'The Anti-Marketeer', *Spectator*, 9 Feb 1991.

8 For a complete list of exhibitions held at the British Museum since 1838 go to www.britishmuseum.org/pdf/RP_Exhibitions_Chronology.pdf.

9 Dora Thornton, *A Rothschild
 Renaissance: Treasures from the
 Waddesdon Bequest*, London, 2015.

<hr>

8 INTO THE TWENTY-FIRST
 CENTURY

1 Typewriter: As1989,04.122; Car,
 Af2000,06.2.a-b.

2 Frances Carey, 'Curatorial Collecting
 in the Twentieth Century', essay in
 Antony Griffiths (ed.), *Landmarks in
 Print Collecting*, pp. 236–45.

3 1975.09.20.2.

4 I am grateful to Frances Carey for this
 insight.

5 Henry Moore to Jocelyn Horner,
 26 Oct 1920. Henry Moore Institute,
 Leeds.

6 Henry Moore to William Rothenstein,
 12 March 1925. Quoted Roger
 Berthoud, The Life of Henry Moore,
 London, 1987, p. 78.

7 Henry Moore, Henry Moore at the
 British Museum, London, 1981, p. 11.

8 2015.8039.1.

9 Email from Jill Cook to the author,
 December 2017.

10 Preface to Marjorie Caygill,
 The British Museum – 250 Years,
 London, 2003, p. 3.

Index